COTTERIDGE
THROUGH TIME
Wendy Pearson

AMBERLEY PUBLISHING

Acknowledgements

The King's Norton History Society is fortunate to have had a number of committed researchers into the history of this area. They include: Helen Goodyer, Stephen Price, George Demidowicz, Frances Hopkins, and James Melling. The Local History Group meet on the afternoon of the first Monday of the month at King's Norton Library include in particular: Brian Bates, Pauline Childs, Myra Dean, Maureen Dickson, Marie Doyle, Frances Hopkins, Peter Marshall, Dorothy Pearson, and Joyce Wakeman. The staff at King's Norton library have been very helpful, especially Triona Sabell. The library houses several archives of photographs both locally and at the Central Library. Various other people have consented to use of their collections of photographs including: Kath Watts, Mark Norton, Graham Thompson, Geoff Dowling, and Peter Shoesmith.

The contribution of other writers and collectors of local history information has been invaluable in trying to find dates and exact locations for some of the early photographs. These include: Professor Carl Chinn, Andrew Maxim, Tom Hill, Alton Douglas, Ray Shill, and Victor Skipp. Dr Mike Hodder, Chief Planning Archaeologist, has been very patient in supplying details from the Sites and Monuments Record (SMR) and in leading walks around various parts of King's Norton. Some of the photographs are duplicated in a number of collections and it has been difficult to track down the author. I apologise for the use of any photograph for which the author has not been contacted for their consent. Although this book is the product of input from various groups I take responsibility for any errors and invite anyone to contribute their knowledge and photographs in order to update the records. Special thanks go to Dorothy Pearson (Mum) who can spot a spelling or grammatical error from a long distance and who proof read the text.

The final thanks go to Amberley Publishing, and especially Sarah Flight for making this book happen.

First published 2011

Amberley Publishing
The Hill, Stroud
Gloucestershire, GL5 4EP

www.amberley-books.com

Copyright © Wendy Pearson, 2011

The right of Wendy Pearson to be identified as the Author of this work has been asserted in accordance with the Copyrights, Designs and Patents Act 1988.

ISBN 978 1 4456 0238 7

British Library Cataloguing in Publication Data.
A catalogue record for this book is available from the British Library.

Typeset in 9.5pt on 12pt Celeste.
Typesetting by Amberley Publishing.
Printed in the UK.

Introduction

Although the village centre of Cotteridge is of late Victorian origin, there has been human activity in the area from the Bronze Age and probably earlier. There was a Roman presence in King's Norton at Parsons Hill, and Longdales Road where the new cemetery has been built, and routes from Alcester to Metchley Fort passed near to where Cotteridge now is. Lifford Lane has the remains of the Roman Road now called Icknield Street.

When William the Conqueror commissioned the Domesday survey, twenty years after he had been crowned King of England, the outcome was produced with a rapidity that showed that the Church, and Anglo-Saxons, had very effective structures of administration. However, the vast Parish of King's Norton was reduced to being an outlier (dependency) of Bromsgrove! In 1916 a separate Parish of St Agnes was formed and this book is largely concerned with this area, and with the farms and industries that influenced the development of a village centre at Cotteridge.

The Cotteridge estate, north of Middleton Hall Road, is identified by relics of moats which were part of the typical medieval landscape of King's Norton. The other local settlements with a recorded history include: Breedon Cross, Lifford, Middleton Hall, Rowheath, and Wychall. A reference in the Lay Subsidy Rolls shows that 'De Hugo de Coderugge paid 11d tax in 1317'. This is the earliest reference that may reasonably be attributed to the name 'Cotteridge'. Cotteridge House was built c. 1680 in Motts Field, a name which refers to a moat, a feature of many thirteenth-century manor houses and substantial farms.

Cotteridge had been in the ownership of the Norton family from at least the mid-fifteenth century. A hundred years later they had become important merchants in Bristol, emphasising the long-distance trading links between King's Norton and the rest of the country, which had probably been established through the wool trade. In the sixteenth century the land from the 'Village Inn' to the current centre of Cotteridge was called Millwardes and ownership can be traced back to the Norton, Field, and Whorwood families. The land passed into the ownership of the Field family and in 1584 Henry Field bequeathed to William Whorwood and his wife, Anne Field, two houses in the village of King's Norton, land called Millwardes, and King's Norton mill.

A reference in 1658 shows a lease from William Berkeley of Cotteridge to a Thomas Pearcie of Worcester. In 1696 an indenture of land including a 'messuage called Cotteridge' was part of a marriage settlement from John Field of the Bells (Bell Farm), to John King of Mereden (Meriden), for John Field's marriage to Elizabeth King. It was attested in 1740. In about 1768 the mill and High House, near the fire station, were sold by Henry Hinckley II to William Guest the younger of 'The Cotteridge'.

The construction of the canals brought a major change to the area, by cutting through estates and providing jobs for teams of 'navvies', blacksmiths and carpenters. Industries quickly developed, often moving from small premises in Birmingham. The trains followed with a particularly complicated loop at Lifford leading to three separate stations being built.

The new wealth being acquired in nineteenth-century Birmingham influenced the leasing of houses and farms to Industrialists in search of a rural retreat. The sale of a 'genteel new built house' with 50 acres of land at Cotteridge which 'may answer a person in Trade that wants a house in the country' shows that the area was desirable. Middle-class homes were built along Middleton Hall Road many had at least two servants and significant gardens with a good view over the Rea valley.

Then the trams and buses came, with the terminus at Cotteridge. The post office with its parcel collection service, the fire station, the police force, and utility services for gas and electricity all provided for the wider community. Major road widening schemes took place. The managers of the industries built their homes in Cotteridge. Look above the retail frontage and see the large detached and semi-detached buildings. Having proved that private contractors could build excellent homes quickly and cheaply, Grants built much of Cotteridge. They often put a date on the building.

The spread of housing for employees from local industries created the need for a shopping centre. Former residences were converted into retail. Familiar names include: Harvey's for haberdashery, Rhodes for china ware, George Mason for groceries. There was a significant presence of TASCOS – the Ten Acres and Stirchley Co-Operative Society – which was set up to enable private enterprise to compete favourably with the bigger chains. The major banks all had offices here.

The next changes came when the church buildings, constructed due to the endeavours of the community, were demolished in the interest of real estate. The park was under threat from lack of funding but now holds an annual procession and CoCoMad. This was again due to the determination of the local community. Cotteridge is a compact village with its own identity. Apart from the shortage of parking spaces it is an interesting shopping centre.

This book is dedicated to the many people who willingly share their local knowledge, memories, and photographs

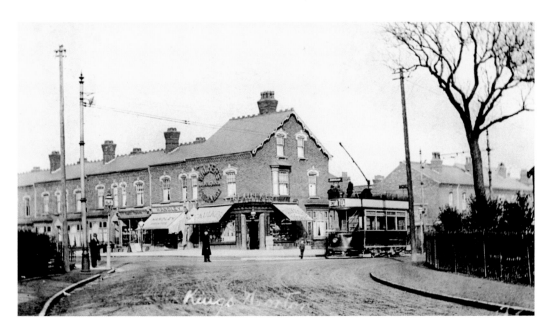

Junction

The above postcard was dated 1910. It certainly wouldn't be appropriate to stand in the middle of the junction today as it is very busy. The road to the left is Watford Road which goes to Bournville, where it becomes the Linden Road, and on to Selly Oak. The tram has reached the terminus and the driver will swing the pole so the tram can head back to the city.

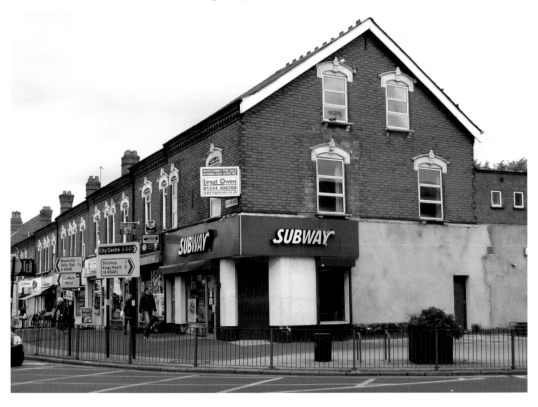

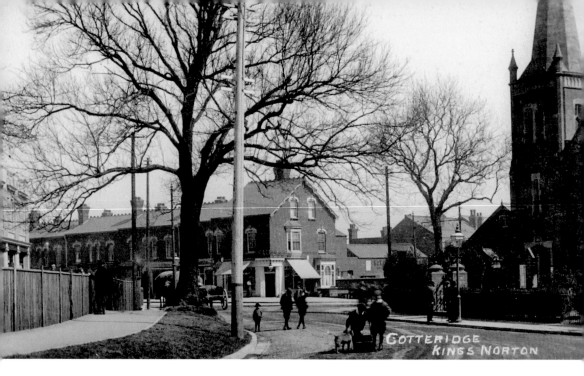

Watford Road Junction

This is the Watford Road junction in 1913. On the right is the Methodist Church, which replaced the former tin tabernacle. The gas showrooms on the left is now a chemist. The fence and trees are gone. There are two traffic islands as this is a busy junction with traffic coming from King's Norton, Northfield, Selly Oak and Stirchley.

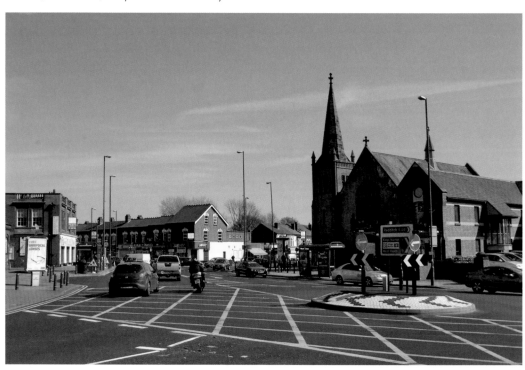

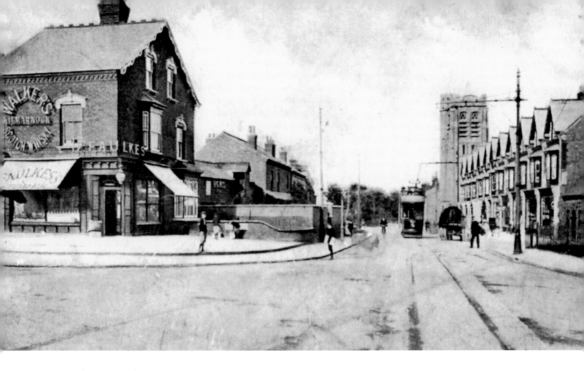

Pershore Road

The Pershore Road is much busier now and barriers prevent people from wandering into the road. The street lighting has improved. Faulkes, the corner shop for many years, became George Mason, and is now Subway. The walled garden has been demolished to open up the centre for pedestrians. Buses now go on to the three estates of Pool Farm, Hawkesley, and Primrose Hill. Retail is still a priority for shoppers and traders.

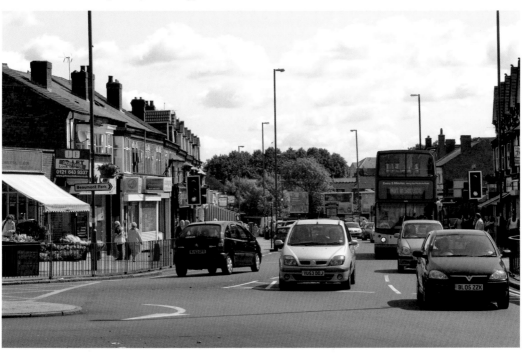

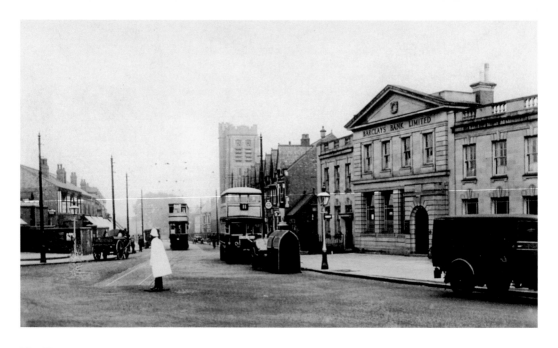

The Tram

The tram is coming from the Breedon Cross and the policeman is standing at the end of the tram tracks. The number 11 bus is by the tram depot which was converted in 1952. St Agnes Church is in the centre. Barclays Bank is now an Italian restaurant, La Banca. When Barclays moved from here, various uses for the building were proposed and contested by local people who were able to see the problems that would arise, in particular, because of the absence of available parking.

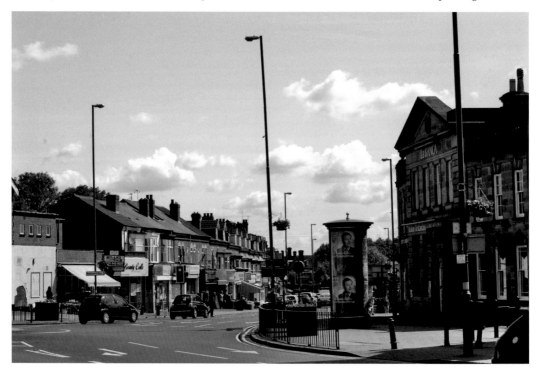

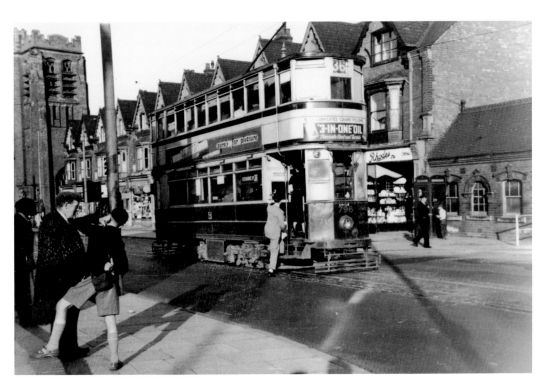

The Tram

Imagine walking into the middle of the road to get on a bus! The public toilets on the right have been replaced by a more sophisticated unit. The conversion of two of the terrace frontages that became Lloyds bank is not entirely sympathetic to the visual appearance of the block of shops.

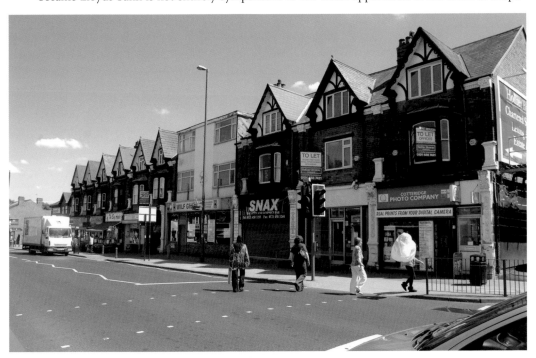

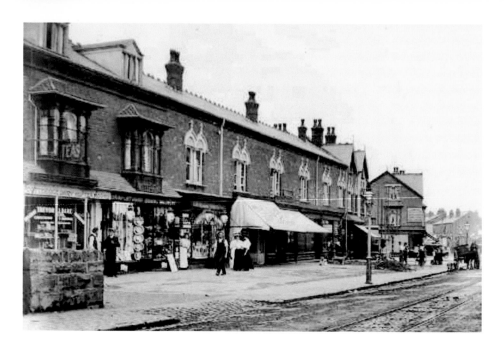

Cotteridge Dairy and Tea Rooms

The first of the two houses with upper bay windows and dormer roof windows were the Cotteridge Dairy and tearooms. The shop on the corner of Midland Road now sells bridal gowns. One of the corner shops was run by TASCOS, the Ten Acres and Stirchley Co-operative Society. A group of traders formed the society to enable competition with bigger concerns. One of the memorable features of the shops was the Lampson invention, where money from purchases was put in a metal container; this was put into a tube and air was blown into an office where the transaction was processed and the change and receipt returned.

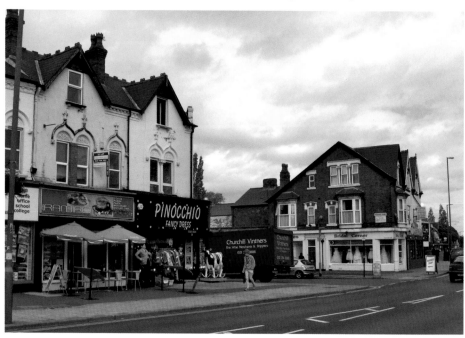

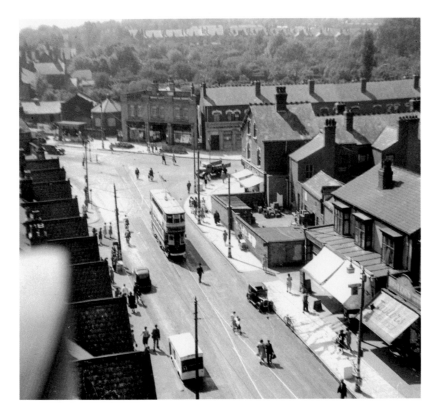

Cotteridge From Above

The top image was taken from the top of St Agnes tower during the Second World War. It seems rather busy with pedestrians who are safely walking across the road. Near the top are the gas showroom and regulator building and the junction with Watford Road. Pedestrians now need the traffic lights to stop the cars, while the traffic needs the barriers to prevent pedestrians from wandering into the road!

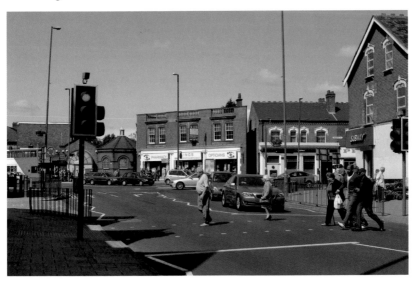

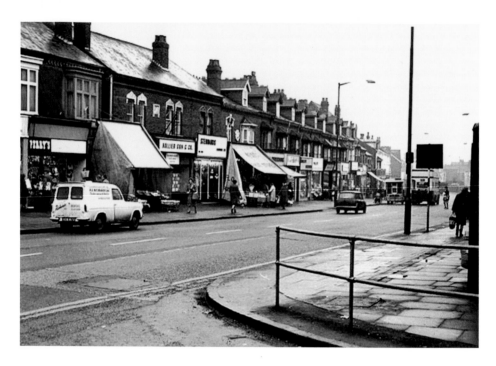

Pershore Road

The gardens have gone and the frontages extend to the public footpath so shopkeepers can display their wares outside. There are several charity shops in Cotteridge. Most of the buildings are geared towards retail rather than other commercial services. Some criminal acts are more depraved than others, like when the Sue Ryder Care charity shop was burgled and set on fire destroying all the Christmas stock. The incident happened in 2005 and thankfully the refurbishment was completed and the shop is back in business, raising funds for the upkeep of homes for people with cancer and multiple sclerosis.

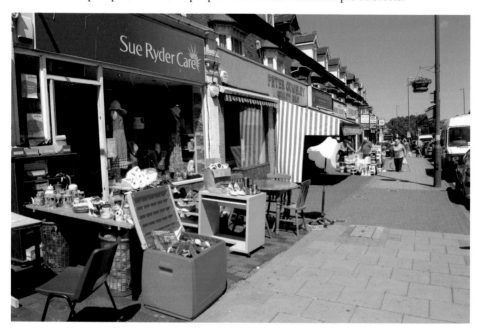

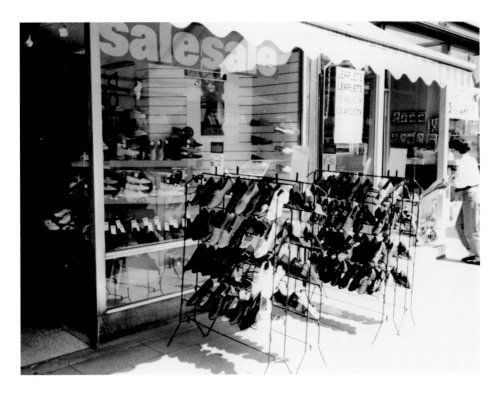

Skinner's

Skinner's replaced Huin's and the shoe fitters. Many people remember trying on some new shoes and being invited to push your feet into a machine which had an X-ray-type effect and could tell whether the shoes fit properly. The different styles of architecture indicate the different builders. The decoration shows the semi-detached houses were clearly important residences before being converted into shops.

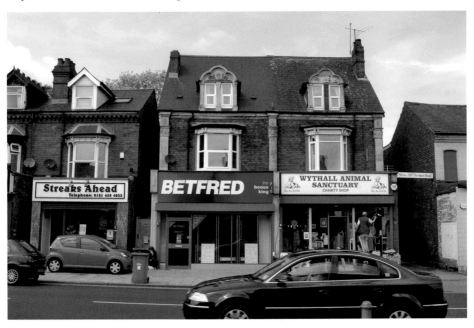

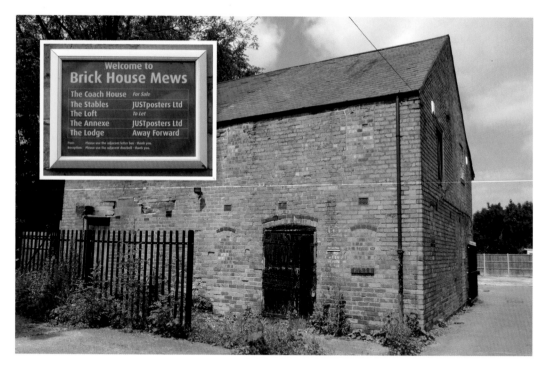

Cotteridge Farm

Beside the Wythall animal sanctuary shop is an alleyway leading to this interesting relic of bygone days. The welcome sign suggests this may once have been part of Cotteridge farm. In such a congested local centre it was a delight to find this well-tended piece of green space – the bowling green for the ex-servicemen's club.

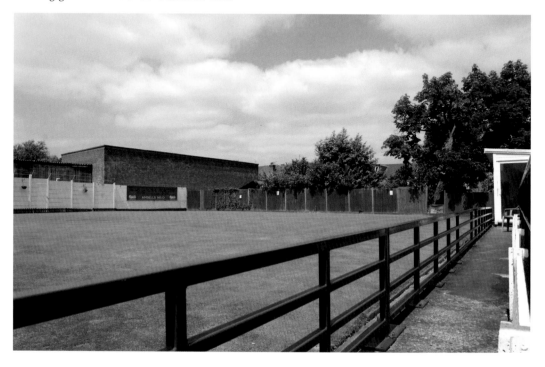

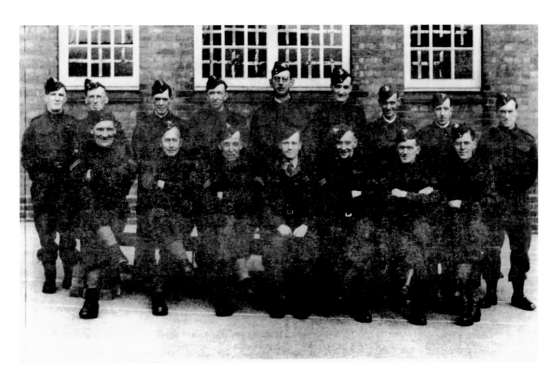

Cotteridge Garage Home Guard

The postcard simply labels this as Cotteridge Garage Home Guard. During the 1914–18 war, a branch of the Worcester Regiment used to drill on this site. With all the industry surrounding it Cotteridge was inevitably vulnerable to bombing attacks. The map identifying where bombs struck show at least seven from Breedon Cross to Cotteridge.

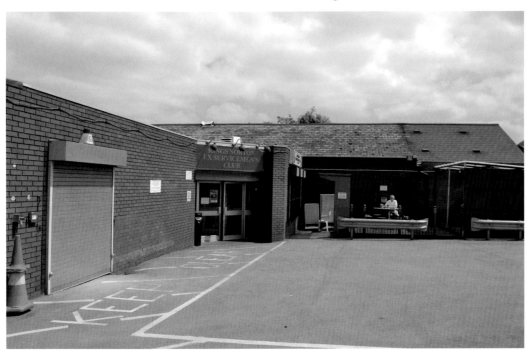

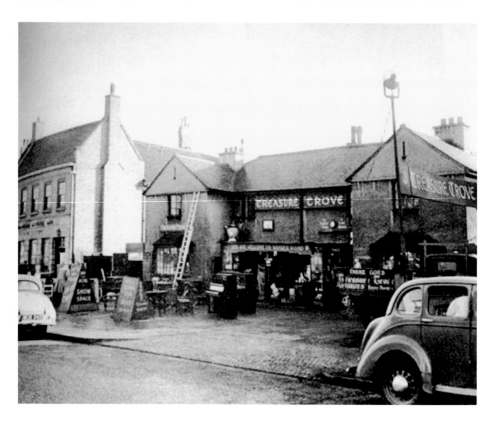

Treasure Trove

Treasure Trove was probably the first shop that any local would refer to. It was an antique shop and had slot machines which children would play on without any intention of purchasing. Inside the doorway was a big stuffed bear which would scare the more timid visitors. It has been replaced by Kwik-Fit.

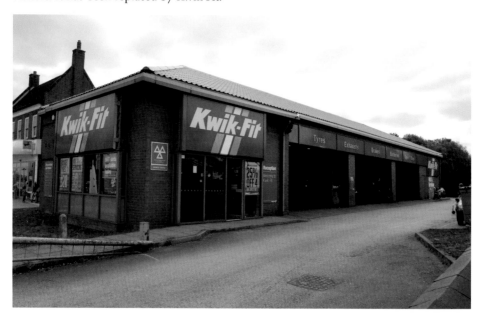

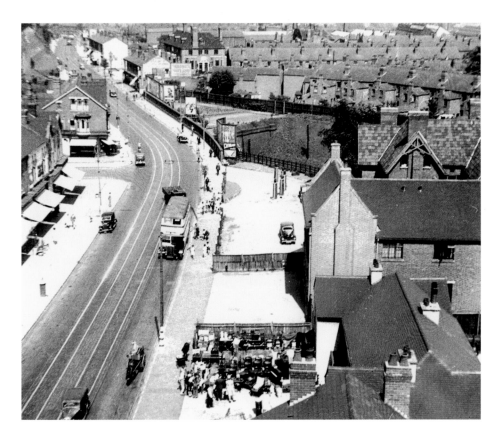

Cotteridge From Above

This is another photograph taken during the war from the top of St Agnes tower. The frontage of Treasure Trove can be seen. Most of the items were brought out in the morning and taken indoors at the close of business. Next is the detached building now Lloyds Bank and just beyond that is the Cotteridge Social Club, which is thought to retain some of the fabric of the much older 'Rookery'.

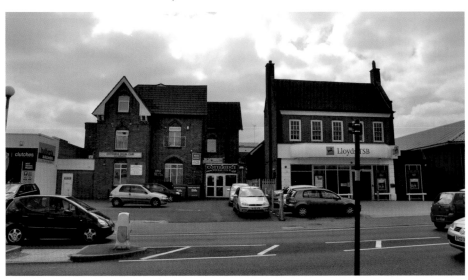

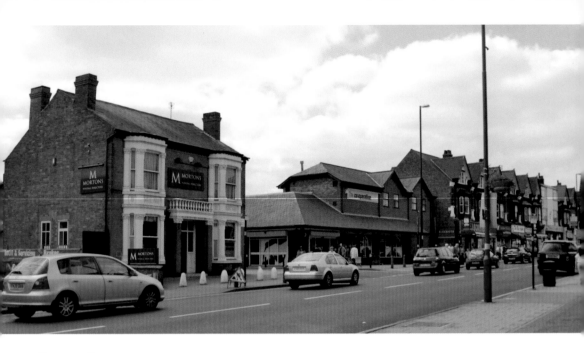

Treasure Trove

This photograph dates to about 1970. Treasure Trove was demolished, but Morton's have ensured the survival of another significant building. St Agnes Church has also gone, demolished in 1985, and replaced by a supermarket.

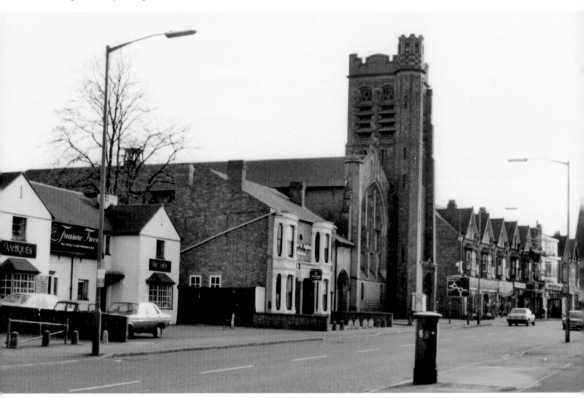

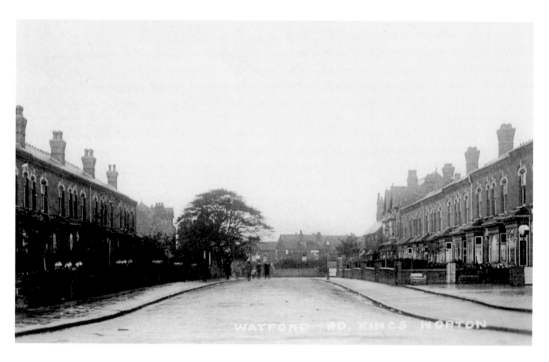

Watford Road

This is Watford Road thought to be about 1907. The gardens have gone in the conversion of homes into shops. The gables to the centre right are where Woolworths had a shop. There are some new buildings including the Spar supermarket and the flats where the Friends Meeting House once stood.

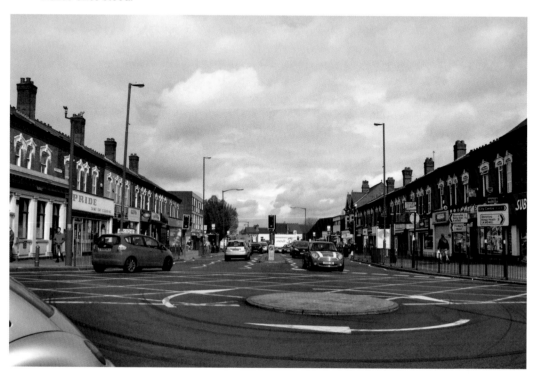

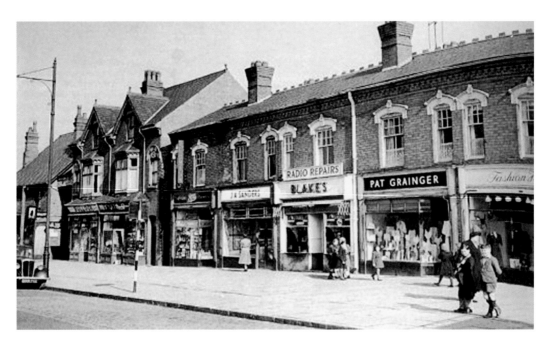

Watford Road

The large house with the gables helps to locate the shops on this side of Watford Road. There has been a fruit and vegetable shop on this site for some years. Kenneth Horne, the radio personality and a director of Triplex, once had a music shop in Cotteridge and provided impromptu local entertainment.

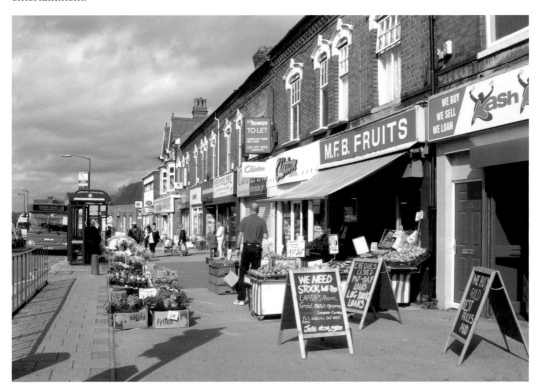

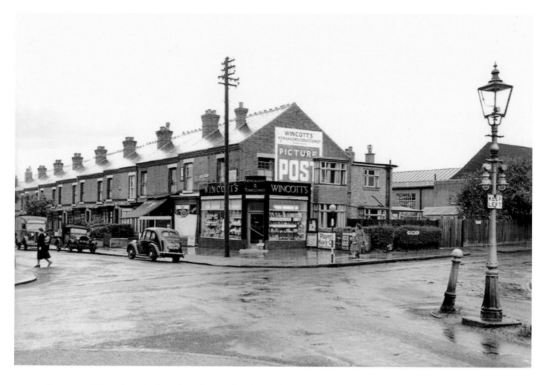

Corner of Rowheath Road and Watford Road

There has been a corner shop and newsagent's on this corner where Rowheath Road meets the Watford Road for a long time. The advertising poster has gone leaving a mark on the wall. Compare the lamppost in the older picture with the new ones. The telegraph post has also changed but not as significantly.

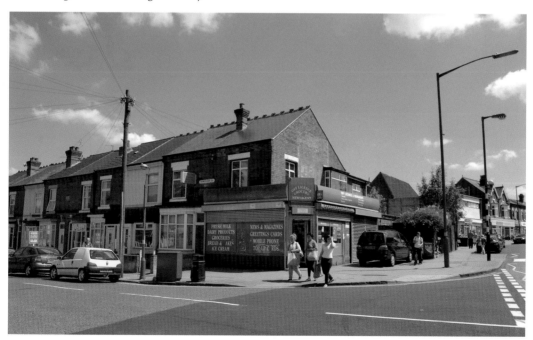

Corner of Midland Road and Rowheath Road

The corner shop where Midland Road meets Rowheath Road has not changed greatly although it sells more fruit and vegetables rather than hardware and household goods.

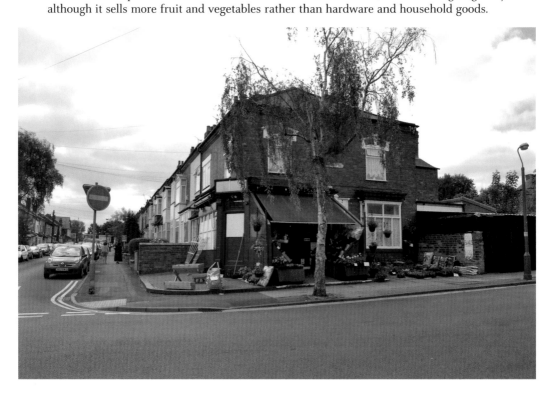

Church Extension in Kings Norton.

New Church at the Cotteridge.

The extraordinary and rapid development of the district immediately surrounding the Parish Church of Kings Norton, and the corresponding increase in the population, has thrown upon the local Clergy and Laity the onus of providing additional accommodation for public worship, or the reproach of permitting the work of the Church to lose ground, which can never be recovered.

During the last decade, extensive manufacturing and building schemes have been carried out in a purely agricultural area.

In 1892, the population was 4,084, ministered to by three Clergy, in one Church and one Mission Room.

In 1902, the population has risen to 12,223, ministered to by six Clergy, in two Churches and two Mission Rooms.

The following works have been successfully undertaken, and are active centres of religious and social life:—

THE COTTERIDGE CHURCH ROOM, licensed December, 1898,
THE WEST HEATH MISSION ROOM, licensed December, 1899,
CHURCH OF THE ASCENSION, STIRCHLY, consecrated October, 1901.

These edifices have cost the sum of £12,500, and there only remains a small debt upon the last named, towards which help will be thankfully received.

We are now engaged in building a Church at the Cotteridge which will cost £10,000, and will provide seating accommodation for 700.

Here in 1892 there were about a score houses, representing a population of about 100. To-day, there are 868 houses, representing a population of 4,300.

The School Board has already provided handsome Schools for 600 children, at a cost of £12,000, and there is every prospect of a further steady development of the district, which will shortly be supplied, under the Local Urban District Council, with a tram service direct to Birmingham.

It is in connection with the erection of the Cotteridge Church that we appeal to that Christian sympathy and support, which the love of God inspires.

The scheme has the hearty approval of the Lord Bishop of the Diocese, of his predecessor, Bishop Perowre, of the Bishop of Coventry, and of the Dean of Worcester, representing the Patrons.

The Birmingham Church Trustees, of whom Viscount Cobham is Chairman, have made a grant of £2,500.

Including this sum, £9,400 has been promised, and, in addition, Mr., Mrs. & Miss Bolliss, of Kings Norton, have generously undertaken the provision of an organ.

It will be seen that much has already been accomplished and many local Churchmen have loyally and liberally promised to assist the project, on behalf of which we now appeal to you. It is manifest that the cost of Church building on so wide a basis cannot be entirely met by local effort, and we earnestly hope that you will be able to stretch out to us a helping hand.

The Building Committee.

REV. C. W. BARNARD, Hon. Treasurer. | MR. THEODORE PRITCHETT, Hon. Secretary.

REV. A. H. PHELIPS	MR. C. F. GRIMLEY	MR. J. W. MARSH
REV. P. E. LORD	MR. F. FAIRHEAD	MR. J. J. MOFFAT
REV. R. SYMES	MR. C. H. FISHER	MR. F. MORTIBOYS
REV. F. G. B. HASTINGS	MR. JAMES HALL	MR. W. S. PRITCHETT
MR. W. J. ADLARD	MR. C. HANDS	MR. M. UDALE
MR. G. E. BELLISS	MR. A. W. KEMP	MR. A. E. WALKER
MR. S. EADES	MR. C. PELHAM LANE, D.L., J.P.	MR. H. J. WALDUCK
MR. J. C. EYRE	MR. W. J. LEWIS	MR. E. H. WARDEN
MR. E. S. GRIFFITHS	MR. F. W. LOCKLEY	MR. G. D. WELDING,

with the Representatives from Stirchley and West Heath.

The following Works are in the Parish:—

MESSRS. CADBURY BROS. LTD. COCOA WORKS.
 ,, BALDWIN'S PAPER MILLS.
 ,, NETTLEFOLD'S LTD. SCREW WORKS.
THE KINGS NORTON METAL COMPANY.
THE TUBLESS PNEUMATIC TYRE & CAPON HEATON COMPANY.
MESSRS. KYNOCH'S LTD.
THE MIDLAND RAILWAY SHEDS.
MESSRS. HUDSON BRO. LTD., TUBE WORKS.
MESSRS. GRANTS LTD., BUILDERS.

There are three Midland Railway Passenger Stations, and a fourth is in process of construction.

Documentation
Documents of this sort provide valuable information for many people. The dates and details give a clear picture of what the village centre was like at the beginning of the twentieth century. Those studying family history may recognise their ancestors.

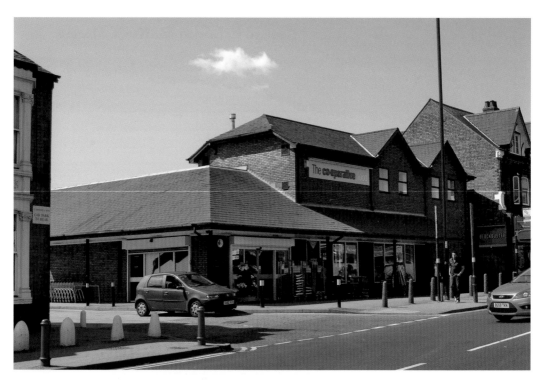

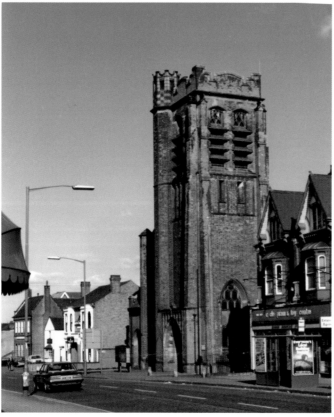

St Agnes Church
The local community united to raise funds to build a permanent church to replace the earlier mission hall. St Agnes Church was consecrated in 1903. It was a daughter church of St Nicolas. In 1916, an ecclesiastical parish was formed separating Cotteridge from Stirchley and King's Norton. In the 1980s proposals were made to amalgamate with the Methodist Church and United Reformed Church. The idea that this would result in their church being demolished was not digested by the local people until the bulldozers moved in.

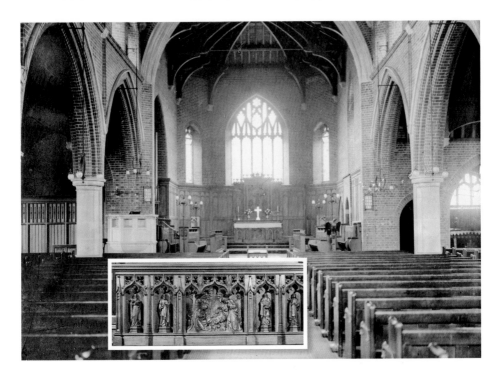

St Agnes Church

The outcome of several years' work was this interior with its quality wood carving. It is fitting that the endeavours of the people who put so much effort into the church should be remembered. Reverend Crump, photographed in 1915, was the first vicar of the parish church.

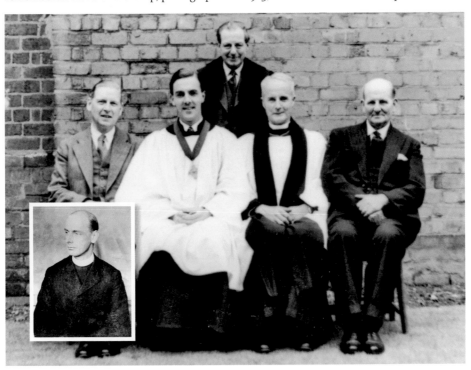

St Agnes Church
The church supported various
local groups and in 1912 St Agnes
Church gave the public a treat with
entertainment. It is hoped that some
memories or personal accounts have
been recorded of this event.

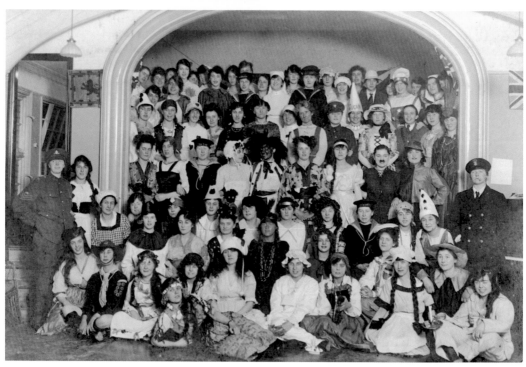

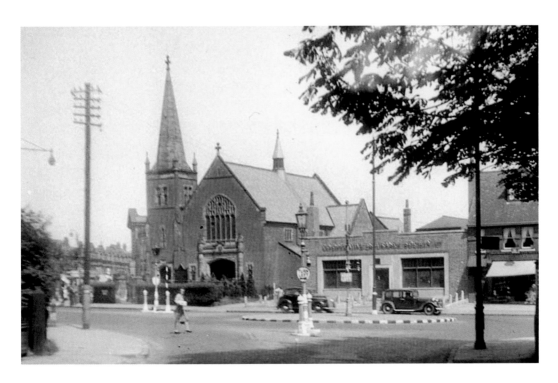

The Cotteridge Church

The Wesleyan Methodists meetings had started in a tin tabernacle but the congregation raised funds for a more substantial building. It became the home of the combined churches and took the name the Cotteridge Church. Cottages on the land to the right were demolished to enable expansion.

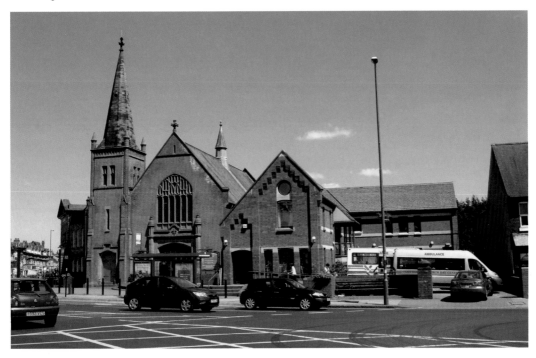

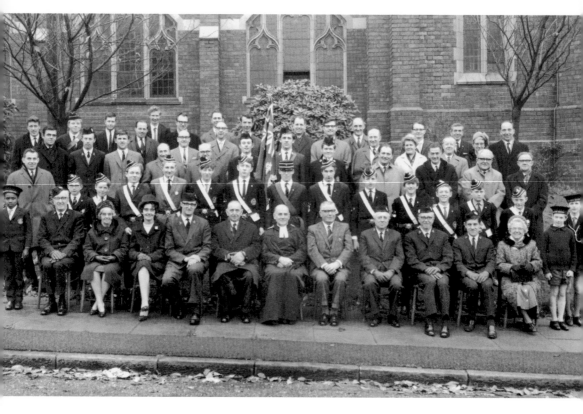

Boys' Brigade

The Boys' Brigade have been an ongoing community group. The 1967 image was taken at the URC church and the centenary was celebrated at the Cotteridge Church after a march around the village. The Birmingham Company of the 7th Brigade began at the Congregational Church until its closure in 1985. The 53rd Company began at the Methodist Church in 1943. The 87th Company ran at St Agnes from 1858–1976. The groups have now merged. There was a Girls' Brigade until they lost their leader.

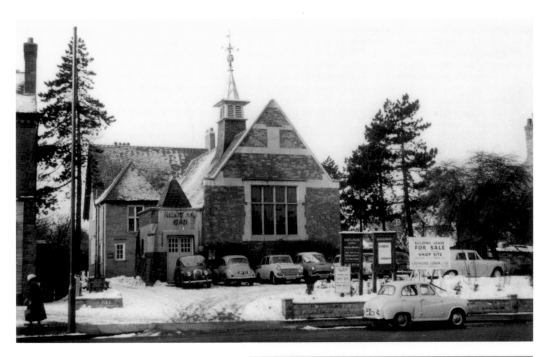

Friends Meeting Place

The Friends Meeting Place was built in 1901. It was rebuilt in 1962. Sadly, this delightful building was demolished and replaced with a block of flats above retail outlets. The group are focusing attention on transforming their building into an exemplar of energy efficiency with zero carbon dioxide emissions.

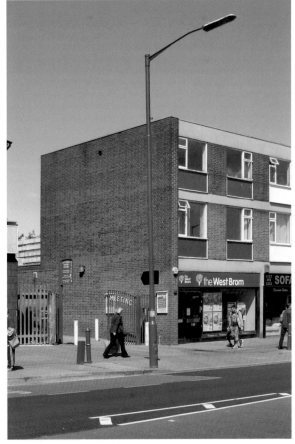

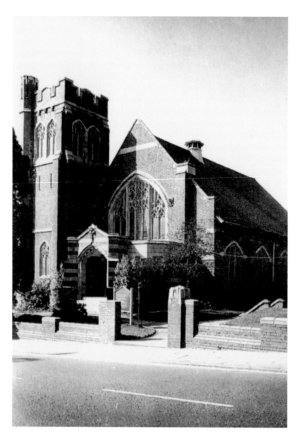

Cotteridge Congregational Church
The Cotteridge Congregational Church began meeting in a hall in 1901. The church was built in 1908 at a cost of £2,395 where Woodfall Avenue meets the Watford Road. In 1953, it became the United Reformed Church and was demolished in 1985. Cherry Tree Court, which is sheltered housing, is now on the site.

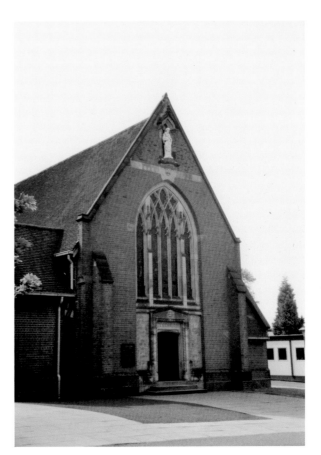

Roman Catholic Church

The Roman Catholic Church of Saint Joseph and Saint Helen began in the tin hut they purchased from the Methodist Church. It now has a brick building and a small school on the site. The school was founded in 1907 and rebuilt in 1994–5.

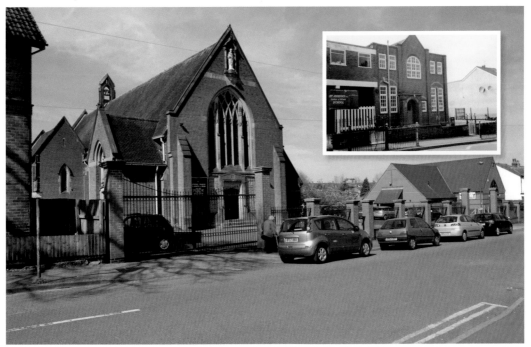

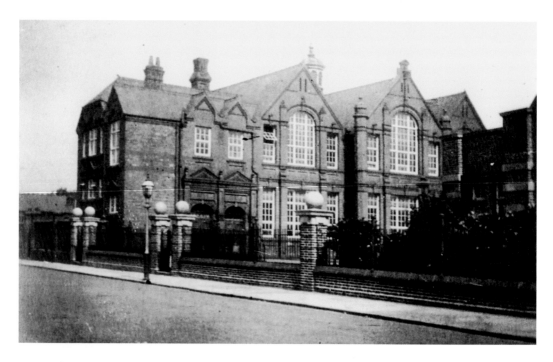

Cotteridge Council School

Cotteridge Board School opened in 1900, with departments for mixed and infant children. A new Infant Department opened in 1911 and the school was reorganised at the same time for boys, girls and infants. It was again reorganised in 1931 into a Senior Girls' Department and a Junior and Infants' Department. The Senior Girls' Department became a separate school in 1945 and closed in 1961.

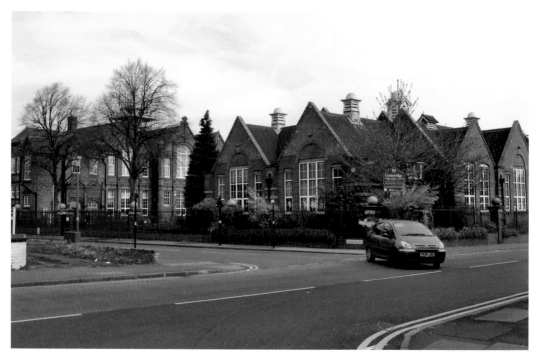

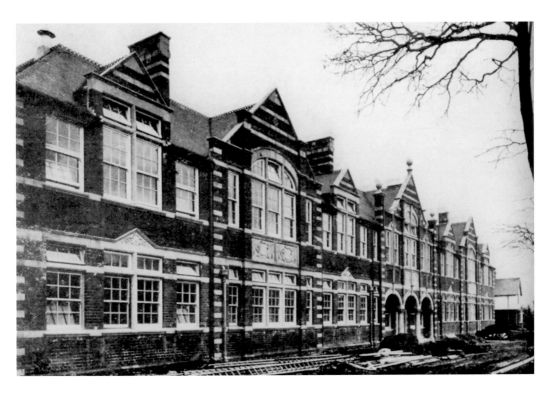

King's Norton Boys Grammar School for Boys

King's Norton Grammar School for Boys was built in 1911, on Northfield Road, to the design of architects Pritchard & Pritchard. Initially it was open to boys and girls. However, by the mid-1920s the school was so successful that a decision was made to build a separate girls school. Enoch Powell (1912–98), whose father was Headmaster of Stirchley School, was a pupil there for a brief period before transferring to King Edwards.

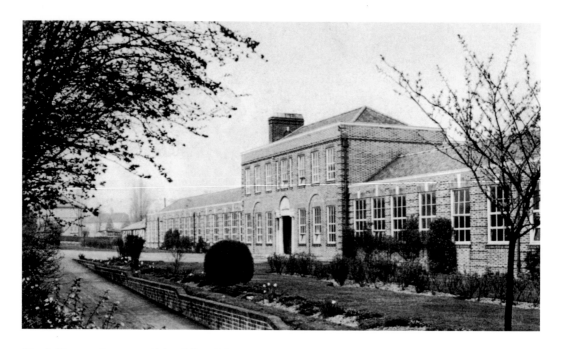

King's Norton Grammar School for Girls

On Wednesday, 12th October 1927, King's Norton Secondary School for Girls was officially opened by Lord Eustace Percy, President of the Board of Education. The school was founded in 1910 as Kings Norton Grammar School for Girls but shared the site in Northfield Road with the boys' school. The school is involved in a range of partnerships with other schools and colleges locally and internationally, and was designated a Specialist Language College in 2001. It became a Leading Edge School in 2003, and gained a second specialism in Sport in 2006.

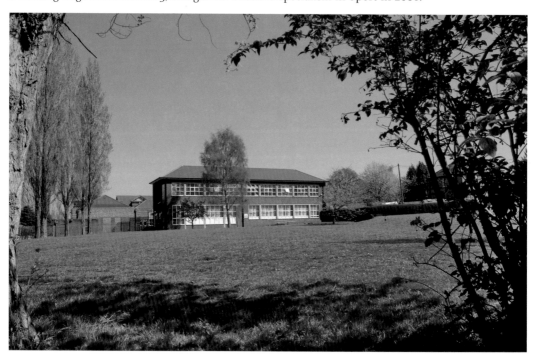

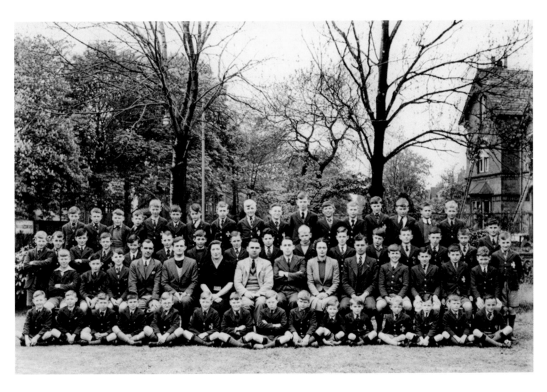

St Nicolas School

This is an intriguing photograph of St Nicolas School, which a former pupil insisted was over the bridge at King's Norton Station. It appears to be a private school possibly run in one of the big villa-type houses in Middleton Hall Road.

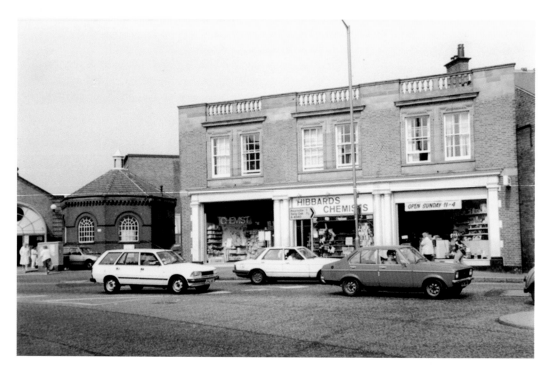

Pharmaceuticals

For many years this was the gas showrooms and office where people could pay their gas bill. Since becoming a chemist it has changed hands but has continued to provide an essential pharmacy service.

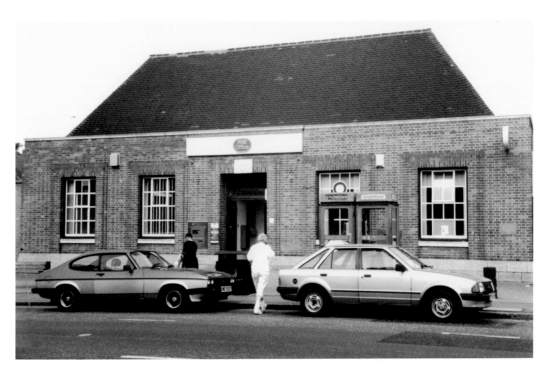

Post Office

A post office was first mentioned in 1905. One existed in Cotteridge on the Pershore Road in 1911. This building photographed in 1992, is now the sorting office with counter services being provided in the Spar supermarket.

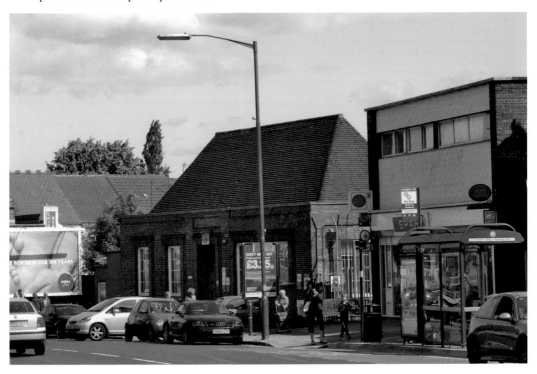

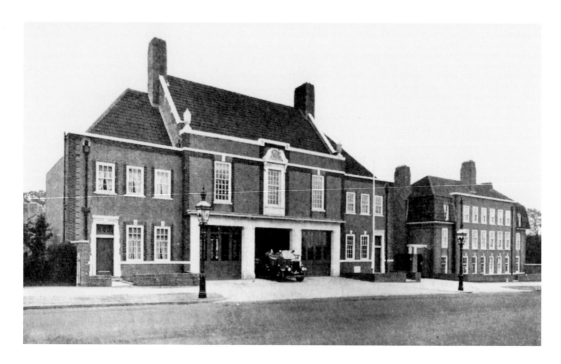

Fire Station

The building has a date of 1930. The main fire station was in Silver Street King's Heath with a substation in Holly Road that was manned by a Mr Cox. The new fire station was built on the site of allotments. Nearby a line of trees used to indicate the avenue leading to High House. One of the former cottages next to the fire station was the electricity showroom and office for paying bills.

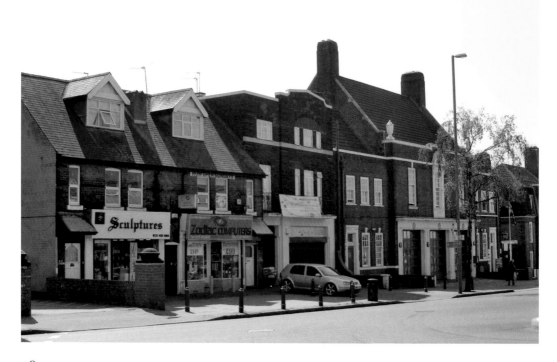

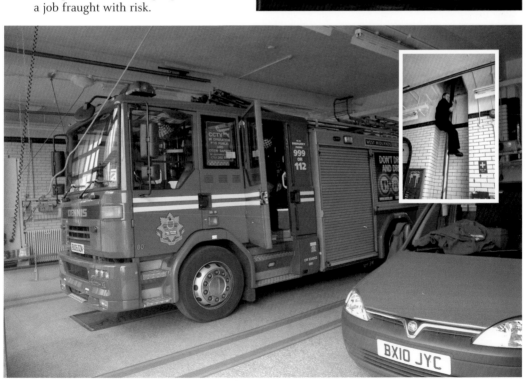

Fire Station

Having jokingly said that photographing public buildings was not allowed, the firemen showed me round the station, and gave a demonstration of sliding down the pole. This prevents the chaos that could arise in an emergency with a group of men rushing down the stairs to go and deal with an incident in which lives could be at risk. Sadly one of the firemen lost his life while responding to a call and a plaque has been posted to remind people that it is a job fraught with risk.

TO THE MEMORY
OF
STATION OFFICER N. GAMMON
OF THE
CITY OF BIRMINGHAM
FIRE BRIGADE

BORN SEPTEMBER 25TH 1883
DIED AUGUST 11TH FROM
INJURIES RECEIVED WHILST
ON DUTY AUGUST 10TH 1936

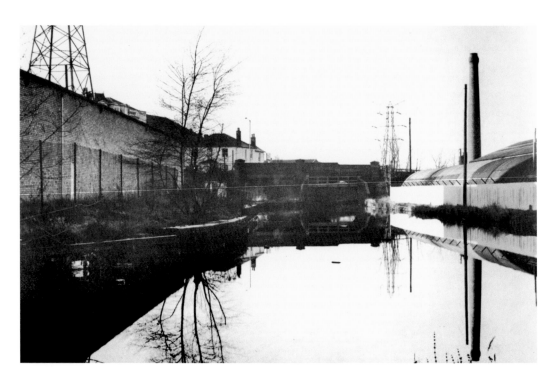

Breedon Cross

This was the wharf at Breedon Cross in 1975. It is just possible to see the roof of Haye House built in 1876 and the National Grid pylon also locates the image. The distant chimney stacks belong to Guest, Keen, and Nettlefolds while that on the right belongs to Hunt's Founders. The towpath and railway are no longer present on the far side of the canal.

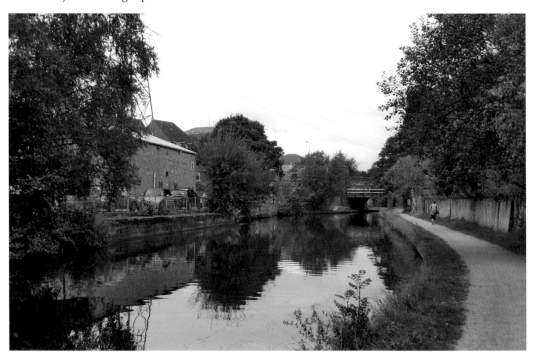

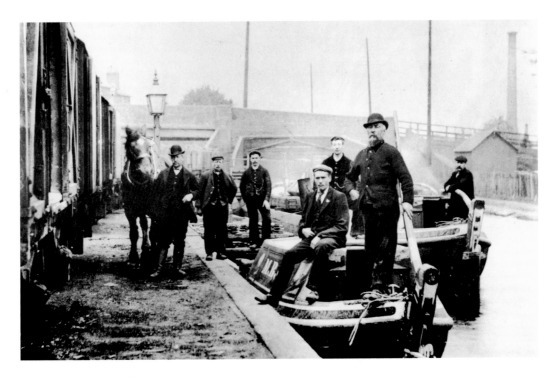

Breedon Wharf

This is Breedon Wharf showing the towpath and railway lines. In the background the bridge takes the canal under the Pershore Road. The canal is a scene for leisure with a canoe group meeting the other side of the bridge.

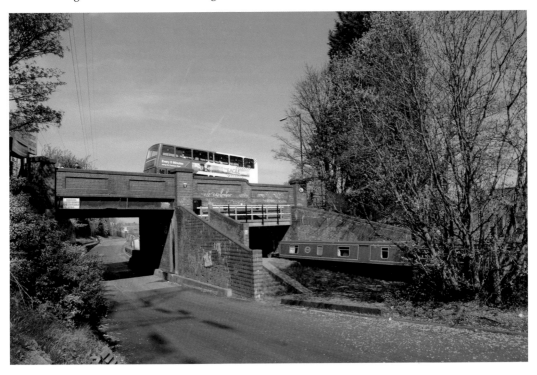

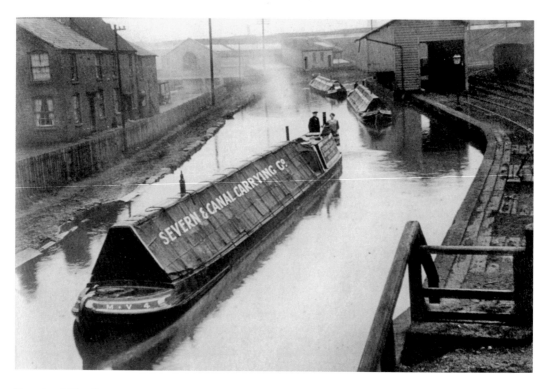

Breedon Wharf
The traffic on the canal transporting raw materials to Birmingham via Selly Oak was perhaps nearly as great as the traffic on the roads today. Motor driven boats would pull a line of other vessels. The location has been identified by the 'kink' on the right-hand side of the canal.

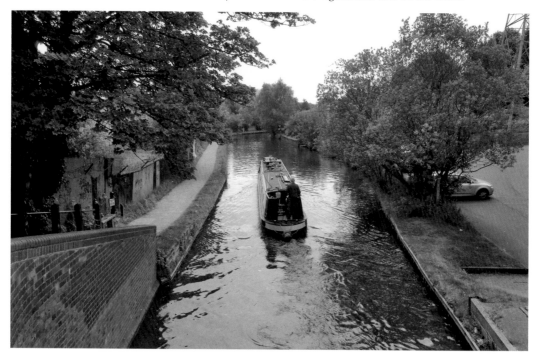

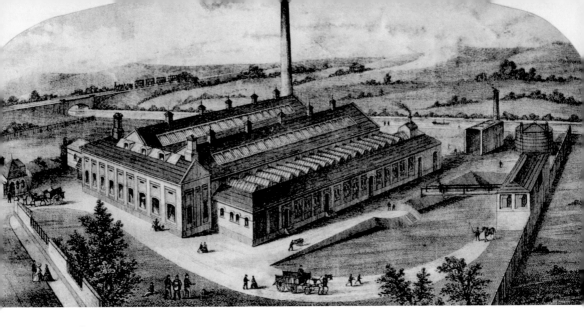

Breedon Cross

Above is a perspective of the Guest, Keen & Nettlefolds factory at Breedon Cross. The company had various changes of name but is most commonly known as GKN. The road to the left of the picture is the Pershore Road, which makes the steep incline up to Breedon Cross. The factory on the right is still present but divided into smaller manufacturing units. The recreation ground has been built on. Near here, an otherwise unknown public house called The Cross has been identified on the 1884 map of Breedon Cross.

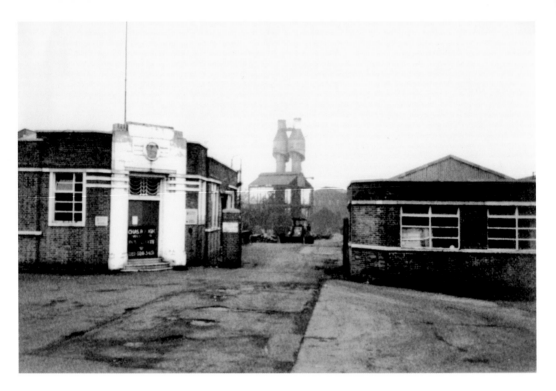

Breedon Cross

R. J. Hunt & Sons, Iron Founders, had a large works on the Stirchley side of the canal at Breedon Cross. They produced cast iron products from scrap and other metal using sand from Bromsgrove. The site is now derelict and will potentially become a small housing estate.

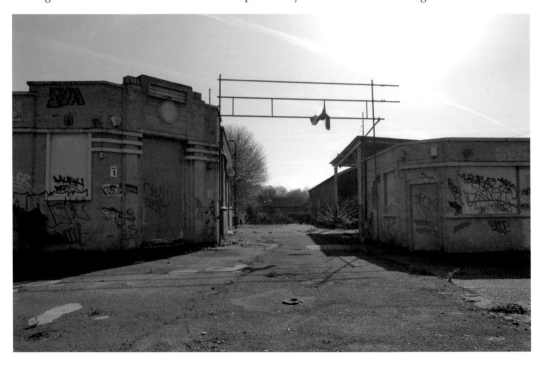

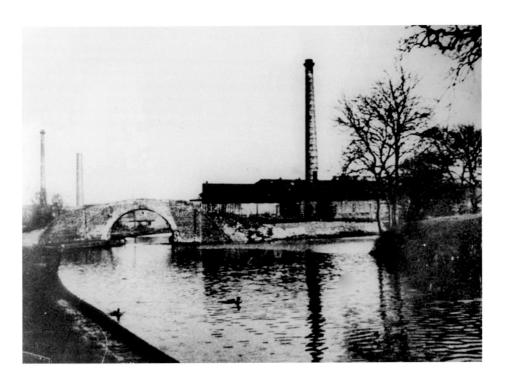

Canal Junction

This is the junction of the Stratford-upon-Avon and Worcester & Birmingham canals. The 1796 Junction House near where the photographer is standing gives the prices of the tolls payable for using the canal. The first section of the canal from King's Norton to Hockley Heath opened in 1796. The chimney stacks to the left were for the King's Norton metal works which is now the Business Centre. In 1918 pennies were minted here and they can be identified by a small KN by the date. The canal turning to the right goes to Lifford. In the middle is the paper mill of James Baldwin.

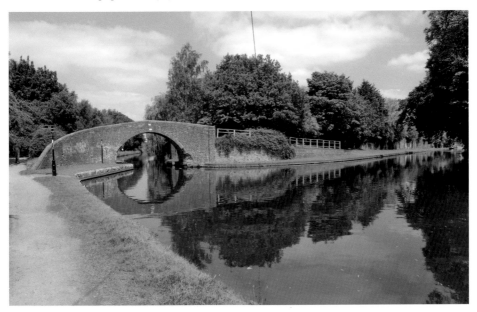

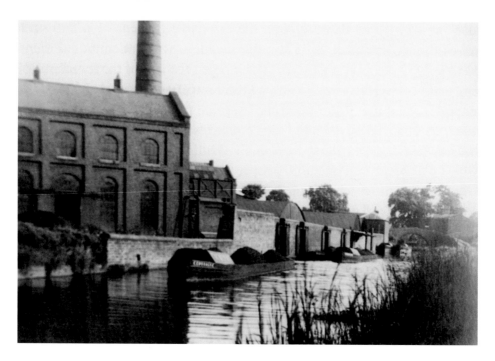

Mills

The bridge near the Junction House can just be seen to the centre right. Baldwin's Mill used steam for their processing. The mill began work in 1836 and finally closed in 1965. It produced paper bags and gun wadding. The buildings were converted to hold the Patrick Collection of vintage cars. It is now called Lakeside Centre and Lombard Rooms. James Baldwin was Mayor of Birmingham in 1853–54 although this mill was in Worcestershire at the time. He also had the smaller Sherborne Mill in Morville Street from 1829.

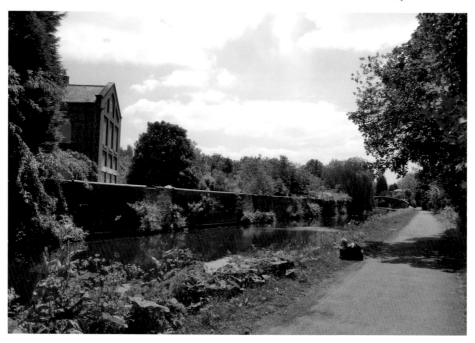

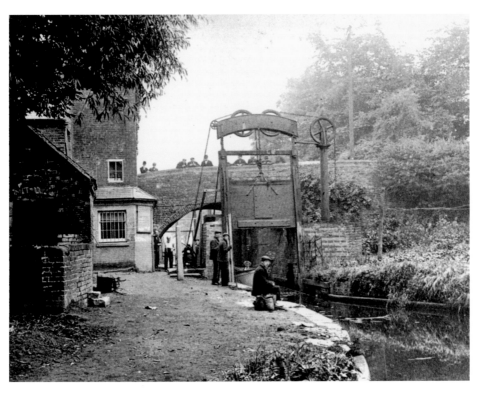

The Canal

This is the guillotine lock with the stables and toll house. The bridge over the canal is Lifford Lane and has since been replaced. Whether there are still fish in the canal is unknown, but it is a very good place for mooring leisure craft while brewing a cup of tea.

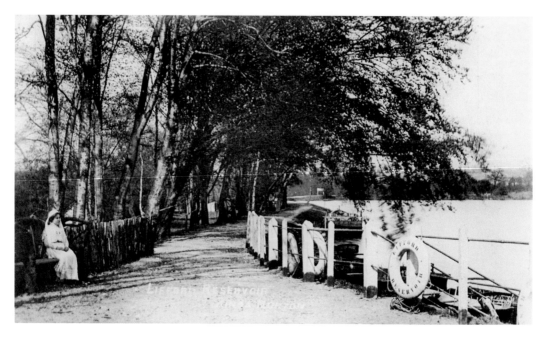

Lifford Mill

The owner of the land adjoining Lifford Mill, Thomas Dobbs, was obliged to release some land for the construction of this reservoir to top up the water levels for the canals. In 1810, he sold 7 acres of land for the reservoir. He gained extra money as a consequence of his dispute.

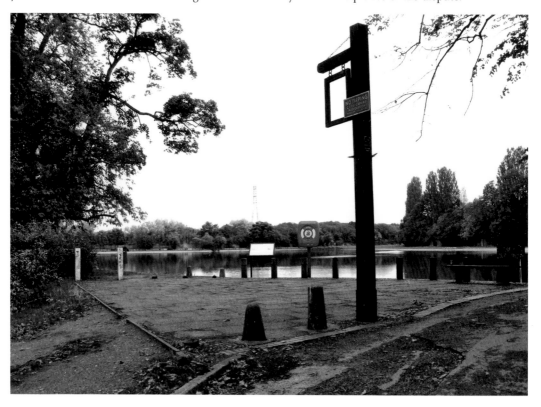

48

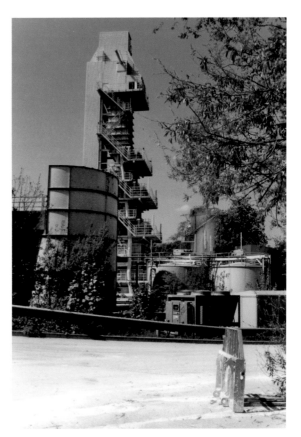

'Vitriol' Works

In the 1830s, when John and Edmund Sturge had their 'Vitriol' works in Selly Oak, they were able to get lime from the kilns which operated on the site later occupied by Goodman's builders merchants. The process moved to Lifford where speciality minerals now process lime in this huge 150-foot-tall kiln which forms a local landmark. Some of the buildings look a lot older and may have been part of the original citric acid works.

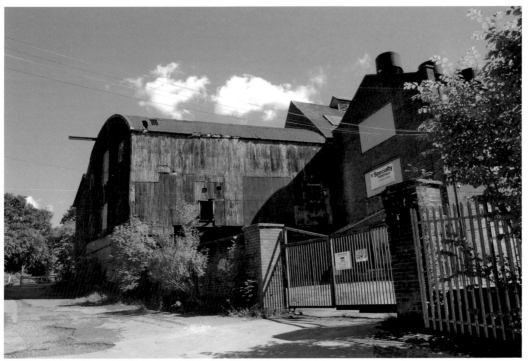

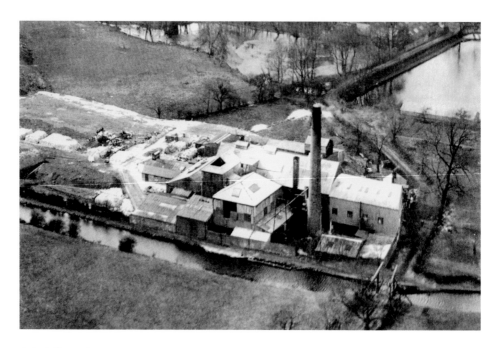

'Vitriol' Works

The aerial photograph makes it easier to locate the position of the chemical works and its relationship with the canal, reservoir, and tunnel lane, which had a roving bridge to allow boats to pass and people to cross from the playing fields into Tunnel Lane. High quality limestone is processed into compounds which form the basis of pharmaceutical tablets, toothpaste, and many other products. Various industrial uses had been made of the mill but in 1945 they were described as old and derelict.

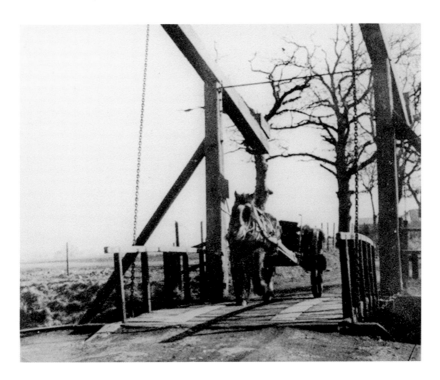

Bridges Over the Canal

The roving bridge across the canal is shown by these two images. The top one shows the earlier drawbridge which could be raised to allow boats to pass. This was later replaced by a fixed bridge. The site is also known for the 'battle of the Cressy' which was when L. T. C. Rolt and P. Scott made a forceful challenge for the right of canal users to be able to pass while walkers were demanding their right of passage along the track. The swing bridge, brought from the Kennet & Avon Canal, was moved into this position in *c.* 1940. Sadly, it suffered a fire and has now gone. It means that people are no longer able to access the reservoir by this means.

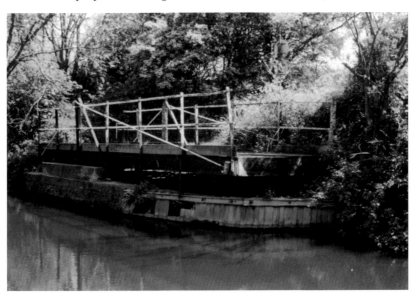

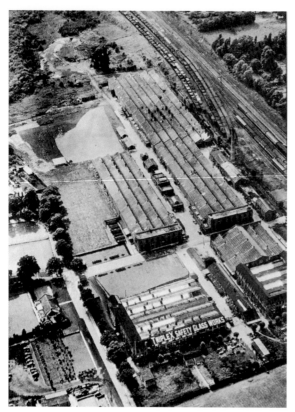

Triplex Works

The Triplex Works is on the other side of the Parish of Cotteridge. There is something of a puzzle as to the large writing on the roof as it seemed to give more guidance to German bombers than serve a useful need. From 1927 they made the reinforced glass for car windows and especially for aeroplanes. The old factory still exists. The football pitch is in regular use as is the bowling green.

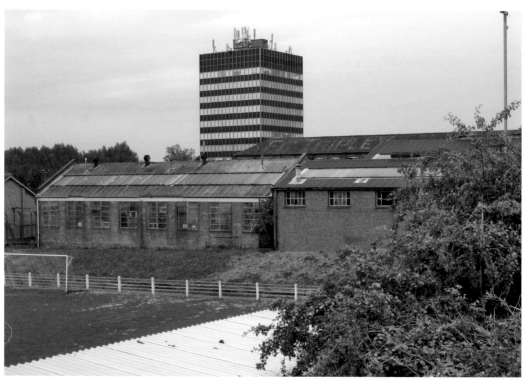

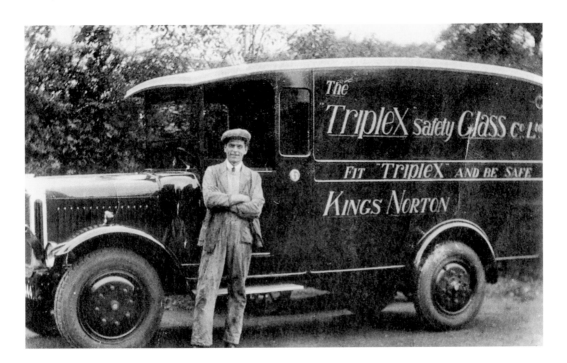

Triplex Works

The Triplex factory, which once supplied the Austin Motor Company, has now become Pilkingtons Aerospace, who manufacture safety glass for the aerospace industry. They produce glass for the home, glazing for special structures, reinforced glass for various trades including the automobile and aviation industries. The factory can be accessed from Eckersall Road on the Catesby Business Park.

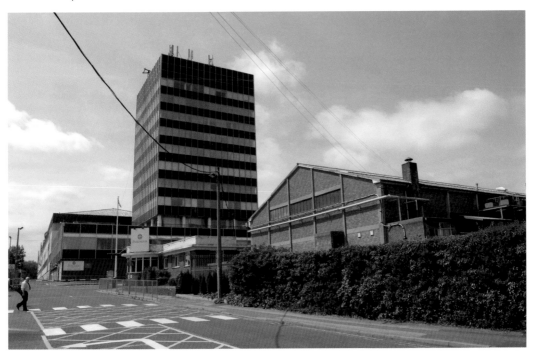

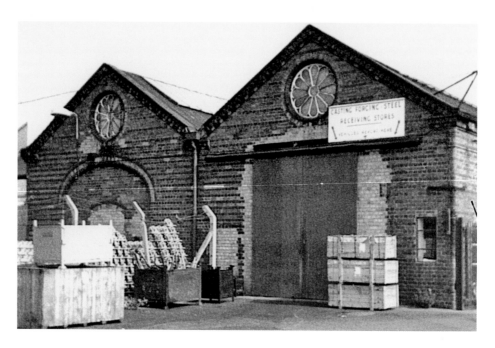

Wychall Mill

Wychall Mill was referred to in a deed dated 1638. With the growth of industrialisation corn mills changed to rolling mills. In 1840, it was owned by Charles Emery who sold it to Charles Ellis & Sons. A steam engine, of the type invented by James Watt, was introduced and they became large scale manufacturers. The site was taken over by Burman's, who were a major employer in the area. They built a factory in 1946 that produced copper-plated machine components for the motor industry. The mill complex became derelict in the 1950s and was demolished in the 1970s. The site has since become several different modern factory units.

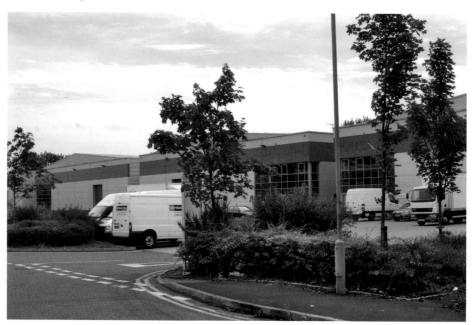

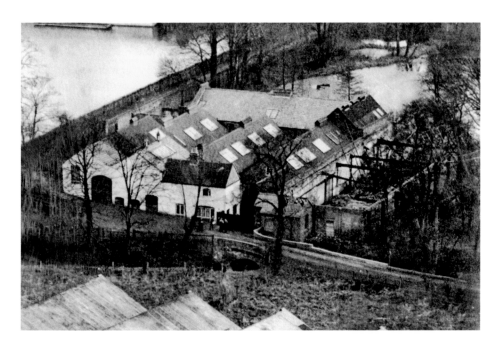

Lifford Mill

Lifford Mill has a long history and the mill buildings are joined to Lifford Hall. Thomas Dobbs converted Lifford Mill to a rolling mill, the first in King's Norton and by 1773 he was receiving orders from the SOHO Manufactory for rolled plated metal and copper to be shipped abroad. Dobbs was also a customer of SOHO and caused consternation to Matthew Boulton when he began making buttons in *c.* 1777. Talk about underground passages was investigated and it was discovered that there were tunnels channelling water for the mill. In 1899, the chemical company of J. & E. Sturge established a new factory in Tunnel Lane. They were taken over first by RTZ Chemicals and in 1990 by Rhône-Poulenc who built the limekiln.

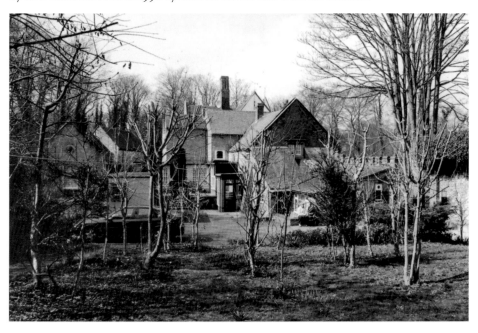

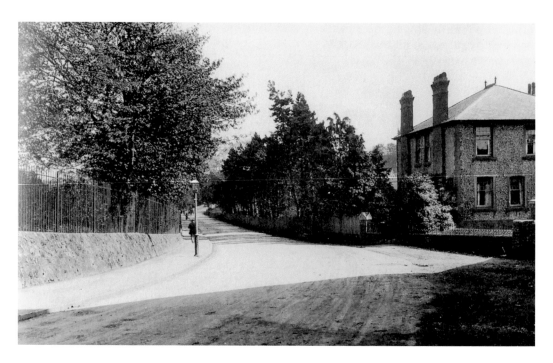

Hurst Mill

This was the manorial mill for King's Norton. It is known as Hurst Mill after the miller Glen Hurst. It was formerly the home of Aaron Jones who died in 1912. Records show it was in the ownership of the Jones family since the sixteenth century. A 1221 reference shows Roger Clarke as the owner. It continued to grind corn until 1940, when it was bought as part of a road widening scheme.

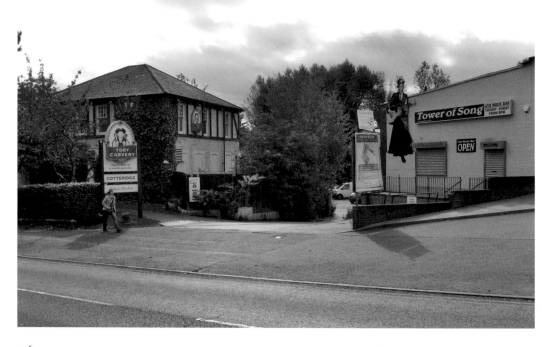

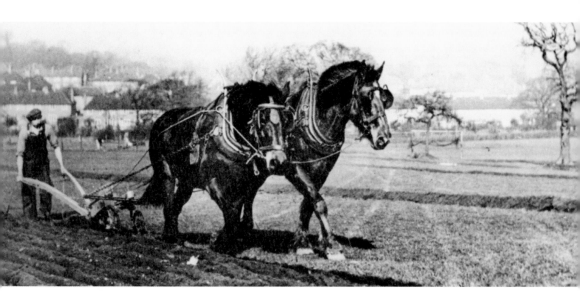

Rowheath Farm

Rowheath Farm had a large acreage and when the Cadbury factory created Bournville part of the land was retained as playing fields. Traditional methods of farming were still being used in the early twentieth century. During the war, it was again used as farmland as basic foodstuffs such as potatoes were in short supply. Some building has taken place including sheltered housing along Heath Road.

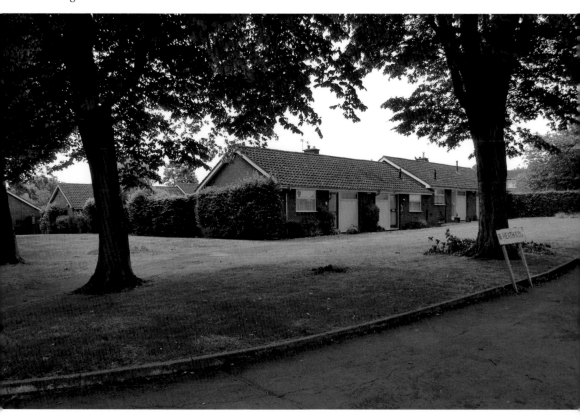

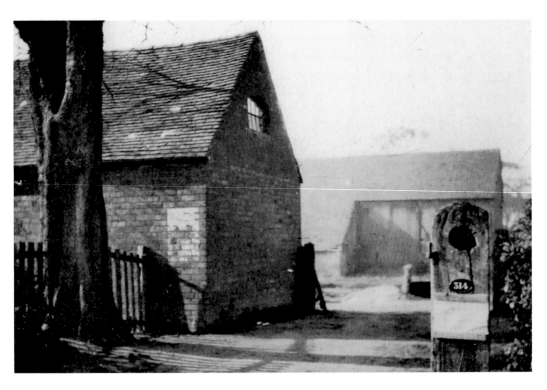

Rowheath Farm

Part of Rowheath, including the lido, was eventually sold for housing. Some of Rowheath Farm buildings, in Oak Farm Road, especially the barn have been converted into homes. The farm was also known as Griggs Farm.

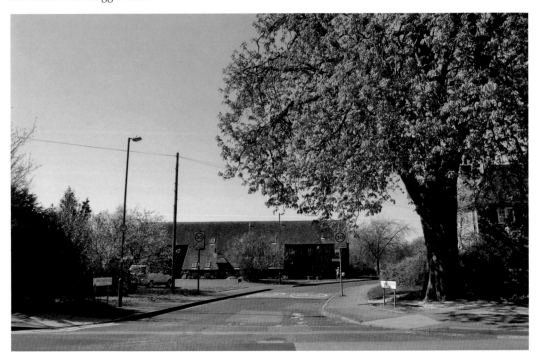

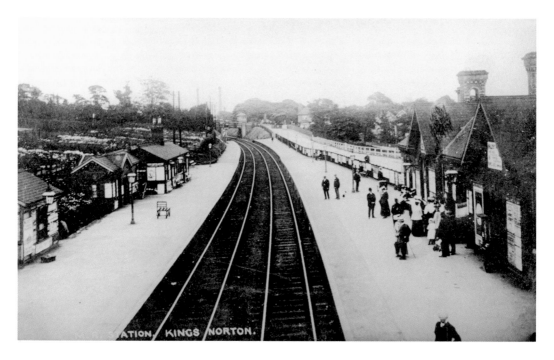

King's Norton Station

King's Norton is one of the oldest stations in Birmingham having been built in 1849. Interestingly, at the time it was built it wasn't actually part of Birmingham. The photograph is dated to about 1907 and shows just two platforms, which were later increased. The old Victorian buildings seemed to disappear without warning and the car park was extended.

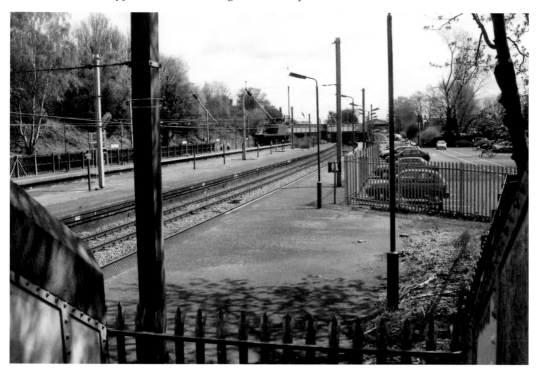

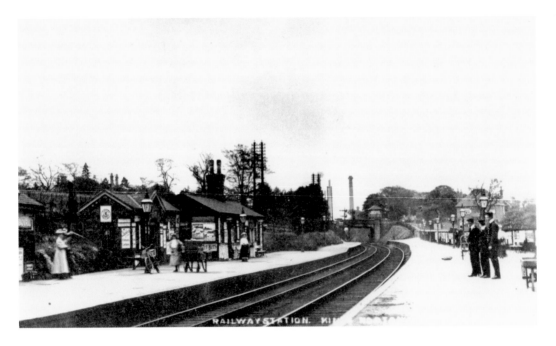

King's Norton Station

Interest in trains was not just restricted to local children. The Reverend Awdry was curate at King's Norton and when his son Christopher was ill and unable to attend school, his father created stories about trains which resulted in the tales of *Thomas the Tank Engine* becoming published. Recently the sign for the station has been amended to include 'for Cotteridge'. The chimney stacks belong to the King's Norton Metal Company. The bridge carries the Pershore Road above the tracks.

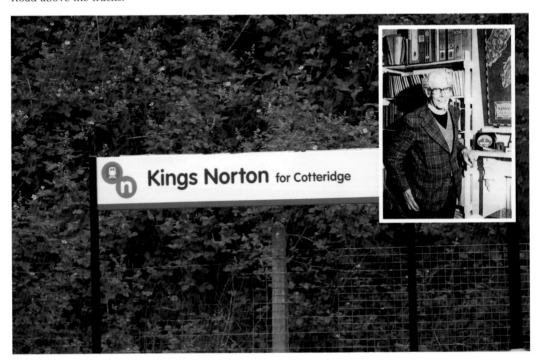

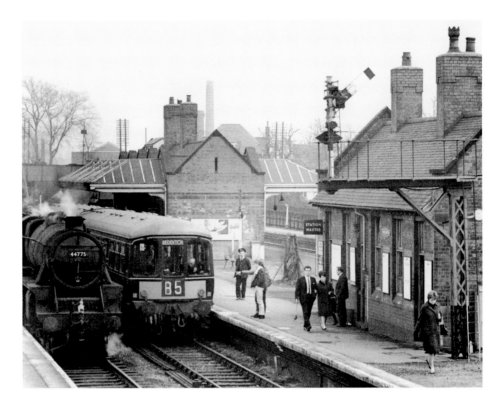

Railway

The photograph was taken by Peter Shoesmith who lived locally. Both trains are heading in the direction of Redditch, although the crossover may send them in different directions. The buildings for the centre platforms didn't survive as long as the older buildings, which can be seen to the centre right of the bottom picture taken in 2003.

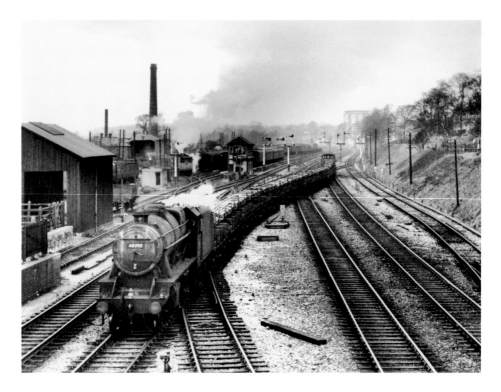

Railway

The railways replaced the canals as carriers of heavy goods, including wood, as seen in this photograph dated 1963. The busy sidings hide the Triplex Factory and the goods yard has been converted into a car park. The Pilkington's building towers over the area which was once Wychall Mill. During the Second World War, hospital trains parked in the sidings ready for the trip to the coast to collect more causalities.

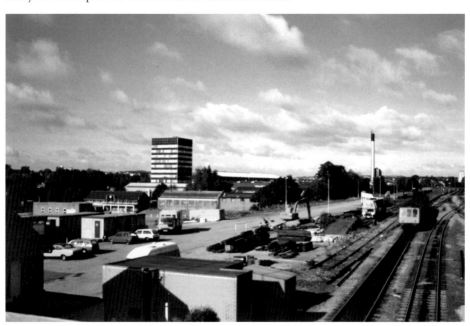

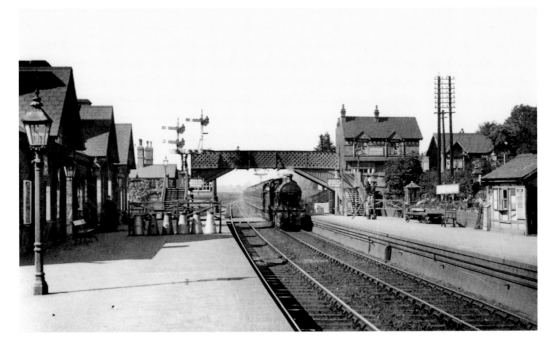

Railway

The photograph above identifies a lot of features about the station that have since disappeared. The metal footbridge replaced the level crossing. The signal box and most of the other buildings have gone. The stationmaster's house can just be seen and is shown below. The row of milk churns is interesting – for whom are they intended?

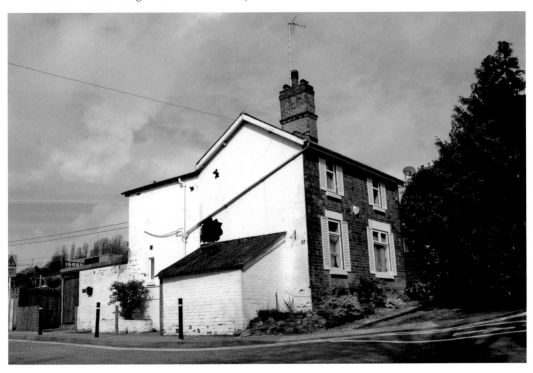

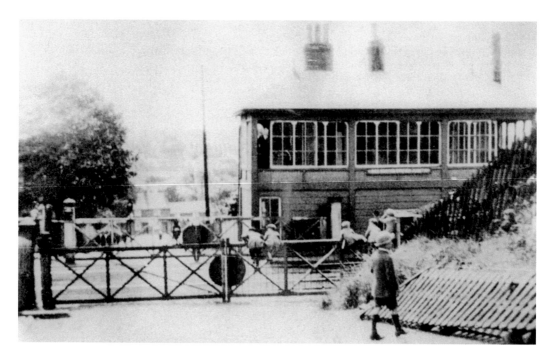

Railway

The level crossing dates to *c.* 1923 and appears to be looking down Station Road towards Camp Lane. There were small industrial units there but the spire of St Nicolas can't be distinguished. At the bottom of the hill is The Camp public house. Facing the road was a row of cottages, where Pressall & Co. were toolmakers.

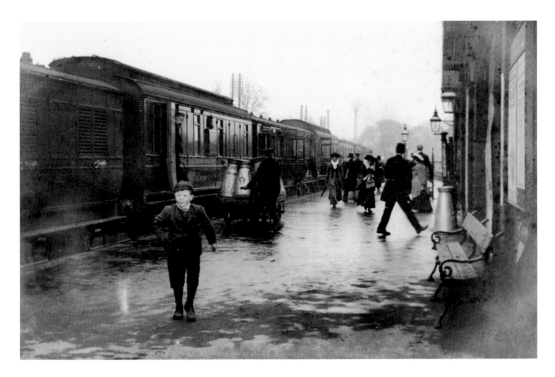

Railway

This photograph is thought to date to 1912 and again milk churns are being loaded. The young boy seems to be on his own although he may not have been a passenger. The scene below shows the same buildings with the new footbridge and Pilkington's in the distance.

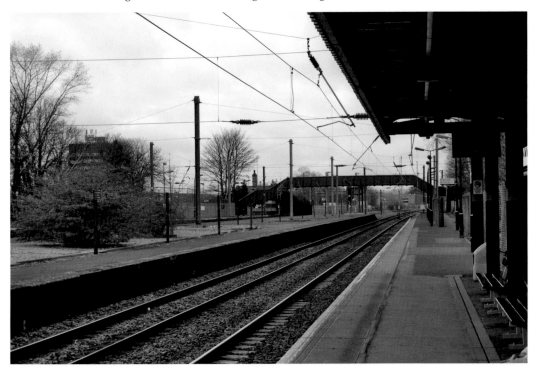

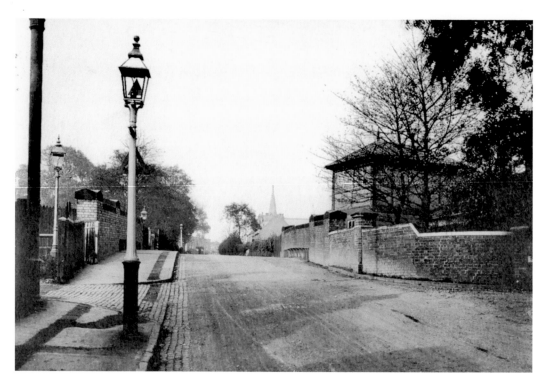

Pershore Road

This is the Pershore Road going up to Cotteridge from King's Norton in *c.* 1924. The spire of the Methodist Church can just be seen along with the fire station and buildings on the site of the Business Centre. The road has become a dual carriageway and Councillor Fryer planted the daffodils.

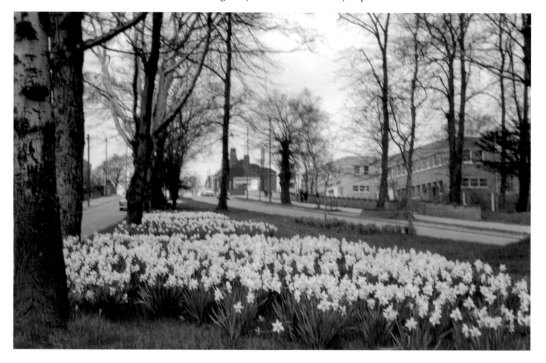

King's Norton Station

The station refreshment room is on the hillside above the station. The site is now the entrance to the station. On the wall of the station is the plaque with the dragonfly and feathers. The motto on the plaque reads: 'The dragonfly and feathers reflect the freedom felt by people who moved here from the crowded inner city.'

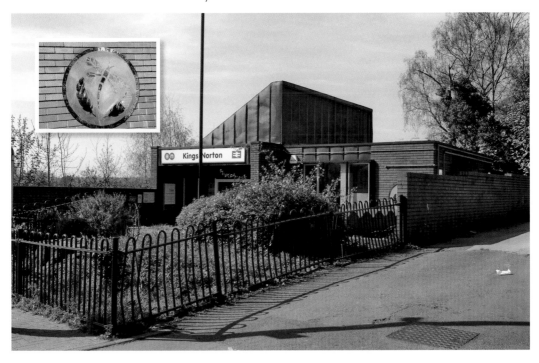

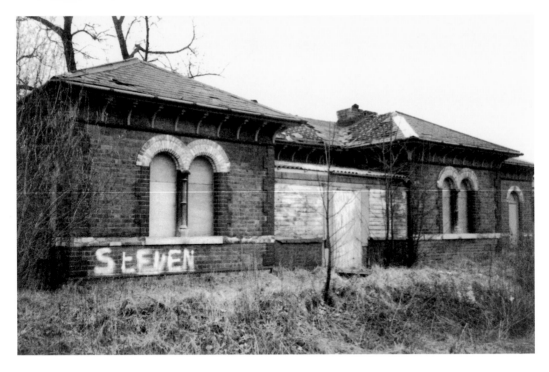

Lifford

This is the Lifford second station in 1984. Lifford had three stations. The first was opened by the Birmingham & Gloucester Railway Company in 1840–44. The BSWR opened a station on its line which closed in 1885. The Birmingham & Gloucester Railway Company opened another station on the Camp Hill line which closed in 1941. The location seems to be near the bridge in Lifford Lane.

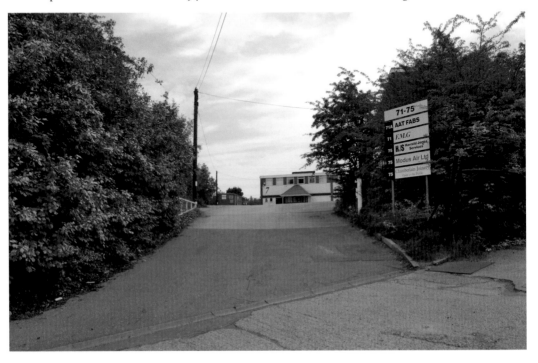

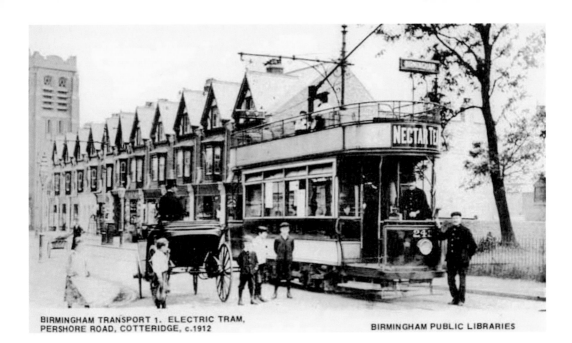

BIRMINGHAM TRANSPORT 1. ELECTRIC TRAM,
PERSHORE ROAD, COTTERIDGE, c.1912 BIRMINGHAM PUBLIC LIBRARIES

St Agnes Church

This postcard is made more delightful by the casual way people can wander into the road.
St Agnes Church had recently been built. The photograph below was taken nearly a century later.
A supermarket has replaced the church and the Photo Company has replaced Rhodes the china
shop. Wilf Gilbert, a betting shop, has replaced Lloyds Bank. The black horse symbol can just be
seen behind the lamppost.

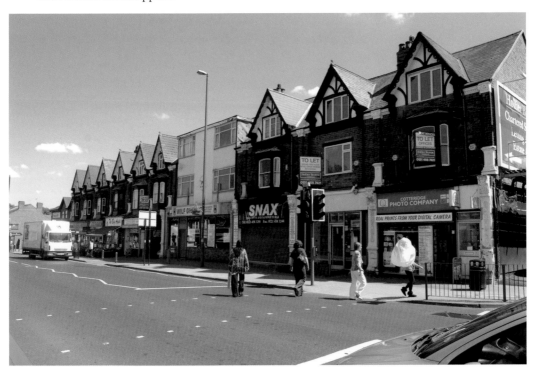

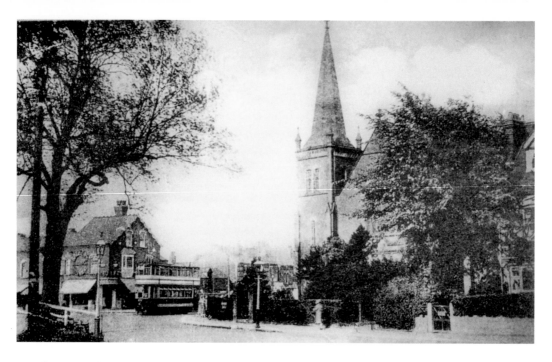

Development of Cotteridge

In 1911, Parliament agreed a Local Authorities Order that created 'Greater Birmingham' by extending the boundaries to absorb much of the ancient parishes of King's Norton and Northfield. This enabled the building of housing estates and the population of Cotteridge rapidly increased. The photograph of the tram terminus above is dated *c.* 1931 and the one below 2011 so it gives an indication of how quickly the development took place.

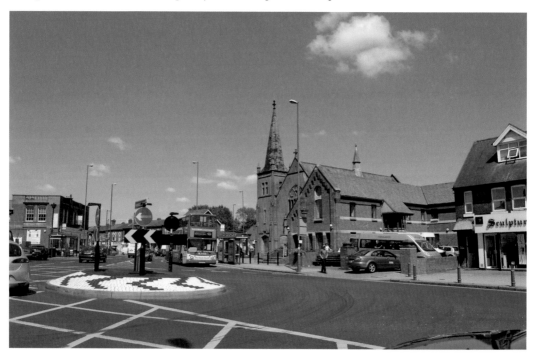

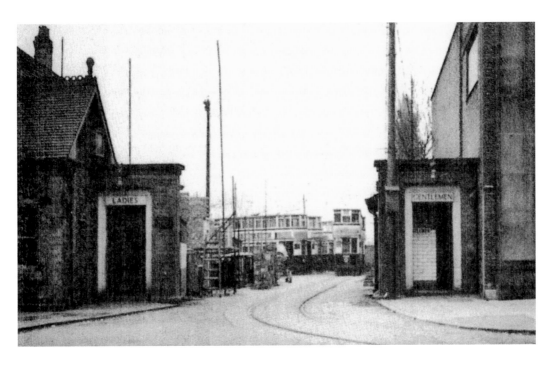

Cotteridge Depot
The Cotteridge Depot was built for the City of Birmingham Tramways Company in 1904 and was acquired for BCT in 1911. It was originally built to hold eight trams but was extended in 1920 to cater for thirty-two trams. It was converted to take buses and finally closed in 1986. The site is now Beaumont Park.

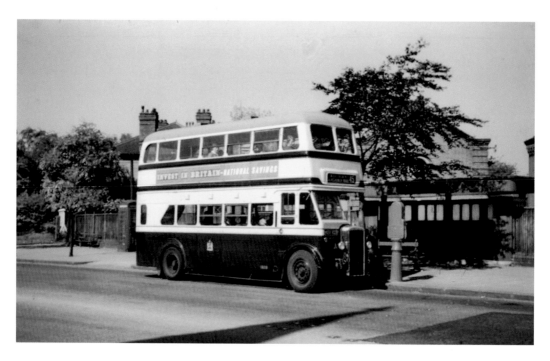

Number 45

The number 45 bus connects King's Norton with the City. Note the clock where the drivers insert a key to record their arrival. The bus shelter has changed. The bench was often occupied by a man known locally as 'Arthur the Tramp', which would now be a derogatory term. There was a sense of loss when he died and efforts were made to determine who he was. Apparently, he was Arthur Mason and went to a junior school in Hockley. Michael Blood, vicar of Cotteridge Church, had apparently traced some of his family and discovered he had been a miner in Australia and also a boxer.

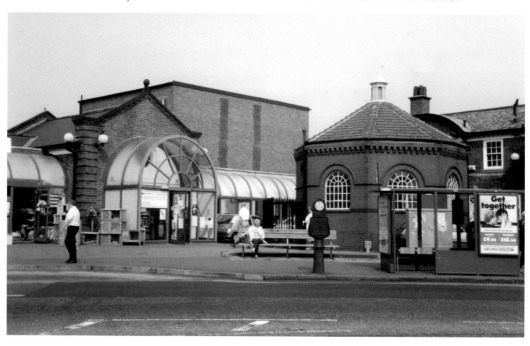

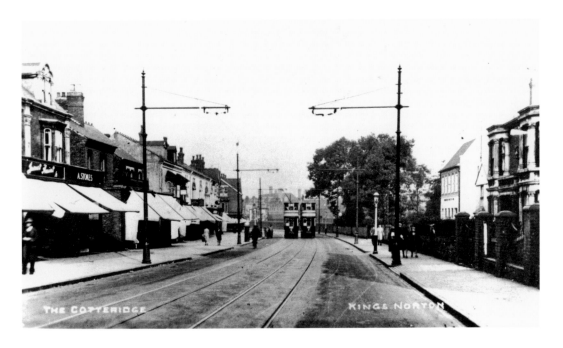

Trams

It is assumed that the trams were going in opposite directions. It is difficult to tell as when the tram reaches the terminus the driver swings the pole on top so the tram doesn't actually need to turn to start the return journey to Birmingham. Awnings are still used to shield wares being displayed in front of the shops there were once small gardens, as can be seen to the right of the picture. The shoe shop belonged to James Huin, which was bought by Skinners, and is now Betfreds.

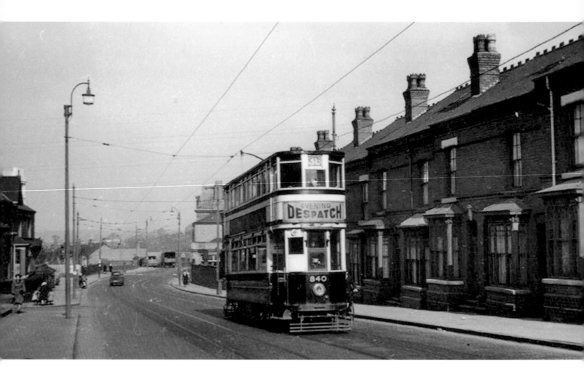

Trams

After the sharp incline from Stirchley to Breedon Cross, there is still a long upward haul to the centre of Cotteridge. This is the end of a ridge of high ground which extends to Sedgley. The tram cables have been replaced with telegraph wires and National Grid cables.

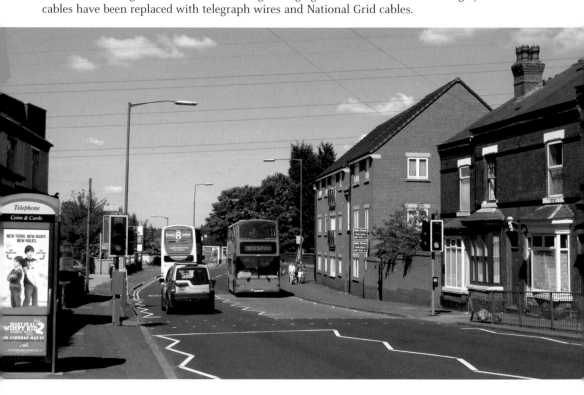

Breedon Cottages

These cottages are known as Breedon Cottages which suggests they were connected with Breedon House, perhaps as residences of the staff. In the bottom photograph the buildings to the far left are Grant Court on the site of Falcon Hill. They can be seen on the 1884 map, which suggests they are rather old. They look somewhat neglected.

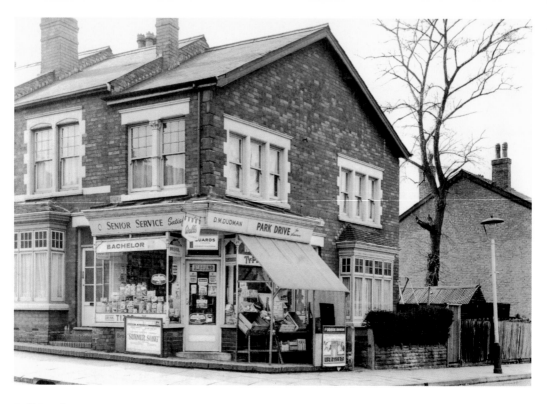

Dell Road

The shop on the corner of Dell Road has been converted back into a residence. Just down the road on the right is the Gospel Hall. On the other corner are the headquarters of the Birmingham Sherborne Sea Cadet Corp.

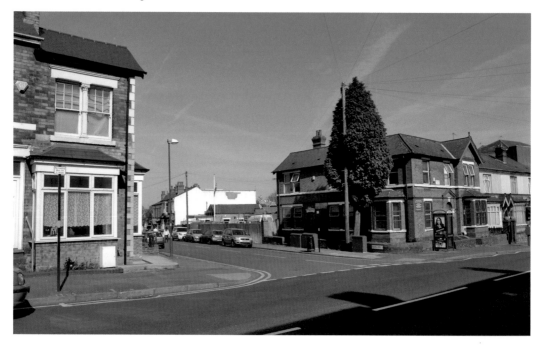

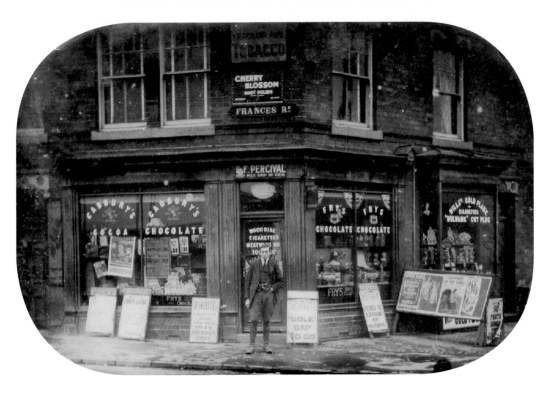

Francis Road

Francis Road still has a few small industrial units. This corner shop has been identified as 'The Cutting Corner', but with replacement windows and cladding on the walls exact identification is difficult. The alternative suggestion is that the house was at the other end of Francis Road next to Lifford Lane.

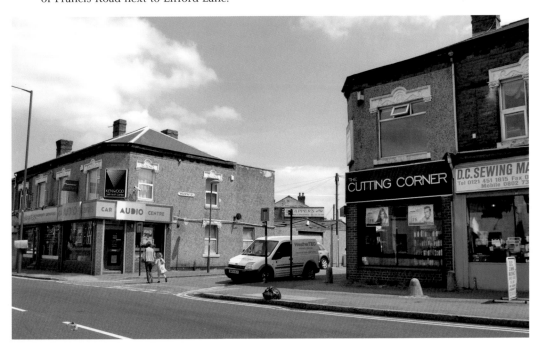

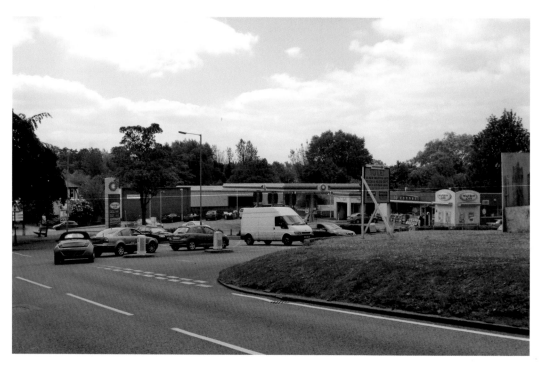

Camp Lane

The spire of St Nicolas Church is easily identified as is the former mill owner's house. A petrol filling station is on the corner of Camp Lane. The mill house is now part of the Village Inn with its regular carvery meals.

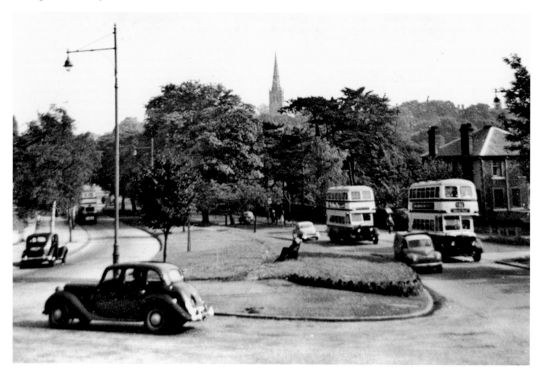

Mail Houses

The 'Mail Houses' changed Britain's landscape. After the First World War, Government and Municipal housing building was very slow. Grant wanted to prove that private contractors could do the job quickly and cheaply without loss of quality. Building work began on 10 November 1919 and the first of the three pairs of houses was completed and occupied by 6 December 1919. The next pair was completed a week later, and the final pair on 9 January 1920. The weather was severe, but normal working hours were observed. The cost was £950. This led to a nationwide boom in house building.

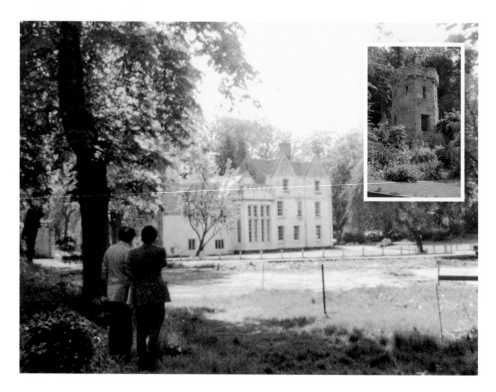

Lifford Hall

Lifford Hall is one of few remaining Country Houses dating back to the seventeenth century when its owner, James Hewitt, became Baron Lichfield. In 1807, Thomas Dobbs owned and lived at the Hall. He also owned the mill. Extensive restoration work has been done and the Hall is now a commercial premises. In the gardens are this Victorian folly and some walling that have led to stories of bishops hiding here during the Civil War!

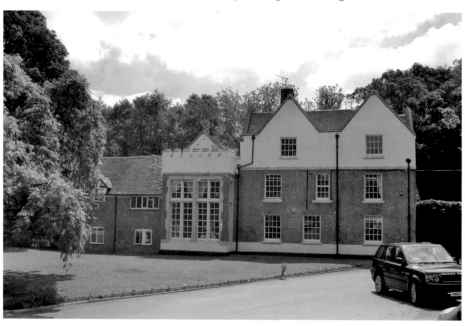

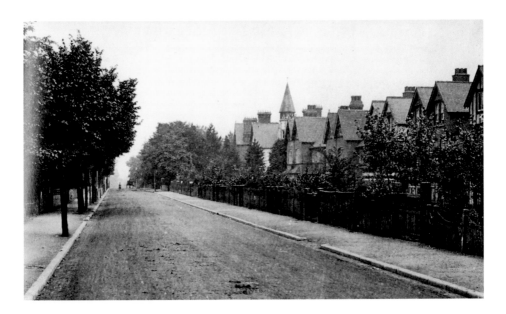

Middleton

The Middleton's were a very old and significant family and Middleton was sometimes confused as the manor instead of Northfield. The land shown was part of the Middleton estate, but it was in King's Norton. The photograph below shows the ancient boundary. The Hall was on the land edged by the corner of Middleton Hall Road and Woodlands Park Road. The straightness of the road is due to its position on top of a ridge that extends to Sedgley. The unusual pointed tower is near to Station Road and may have been where a private school was being run. On the right, Popes Lane is the medieval boundary between King's Norton and Northfield.

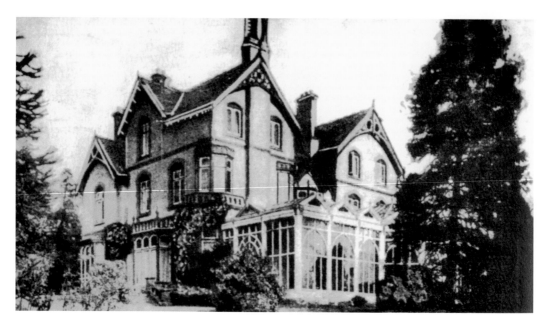

Middleton Hall Road

The late nineteenth century saw the building of middle-class villa residences in Middleton Hall Road. The road was cut through the ancient moated site of Cotteridge. The Dell House was built for George Belliss, who was served by ten resident staff. It was built *c.* 1870 close to the boundary with Northfield and boasted extensive gardens, greenhouses, fourteen acres of land and its own 'farmery'. The house was demolished and this space shows the view the residents would have had over part of the Rea Valley up to King's Norton Village.

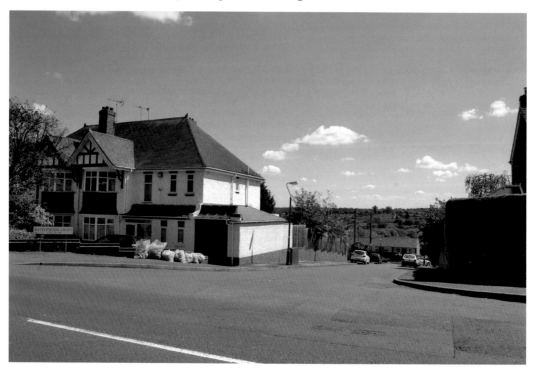

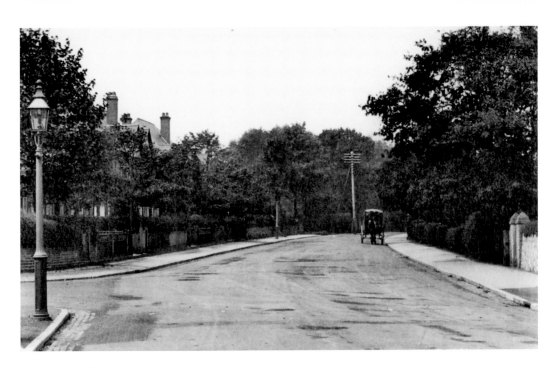

Northfield Road

This is Northfield Road, *c.* 1910. It has been suggested that the road to the left is Station Road, however, in the absence of a crossroad the alternative choice is that it is by Heath Road. Apparently, the Number 18 bus had to use Northfield Road because of complaints from the people living in high status houses along Middleton Hall Road.

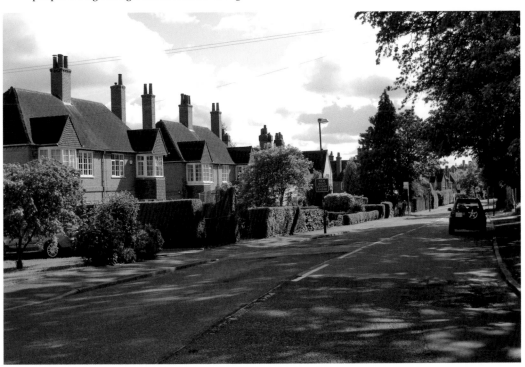

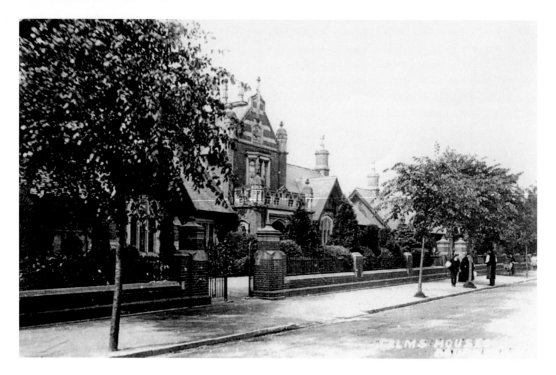

Almshouses

The almshouses were initiated by Richard Cadbury, who sadly died of diphtheria in 1899 while on holiday and he didn't see the first tenants move in. The sheltered accommodation is constructed as low level and single storey bungalows arranged around a quadrangle.

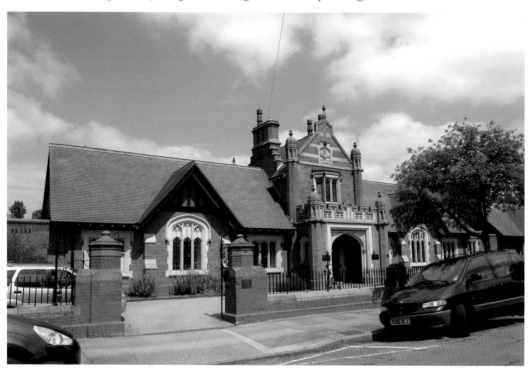

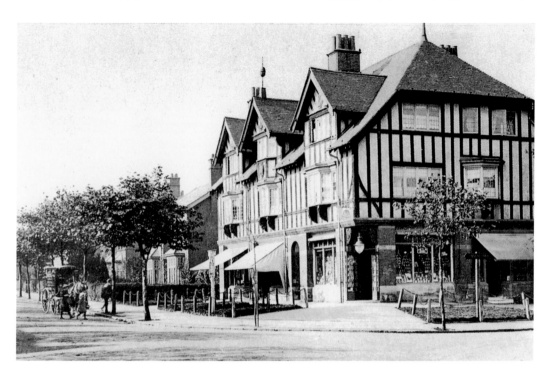

Bournville

These were the first shops built in 1892 after the new Bournville estate was created. They were a baker, drapers and grocery store. The architecture of half-timbered and rough cast with small leaded windows was influenced by R. N. Shaw.

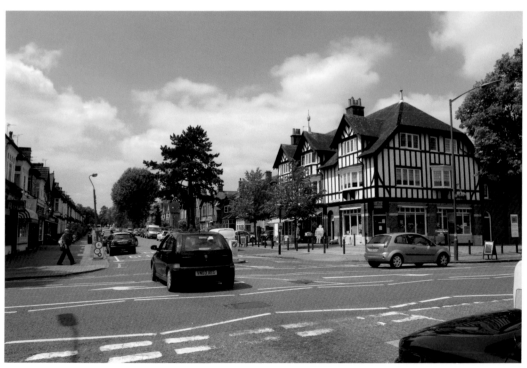

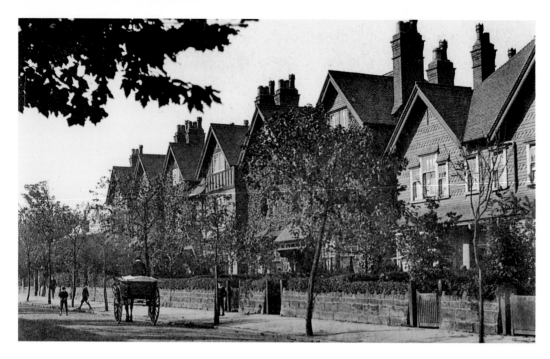

Maryvale Road

The Parish boundary of St Agnes runs down the centre of Maryvale Road. Building of the first houses began in 1895 to designs of William Alexander Harvey (1875–1951), and Alfred Walker. The painted rough cast with corner buttresses was influenced by Charles Voysey (1857–1941). Initially thirty-eight houses were built to provide funds for running the alms-houses.

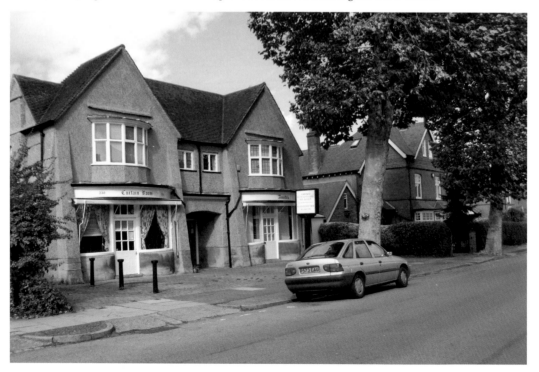

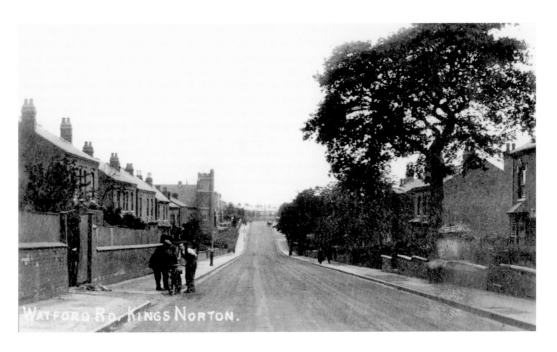

Watford Road

Watford Road heads towards Bournville where it becomes the Linden Road and then on to Selly Oak where it becomes Oak Tree Lane. This photograph was taken *c.* 1905 before the Congregational Church had become the United Reform Church and now Cherry Tree flats. It wasn't a tram route but is now well served by Number 11 'Outer Circle' buses. These come from King's Heath via Fordhouse Lane and up the Breedon Hill to Cotteridge, and then on to Selly Oak.

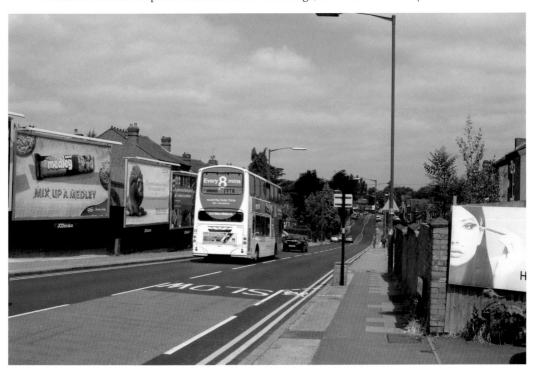

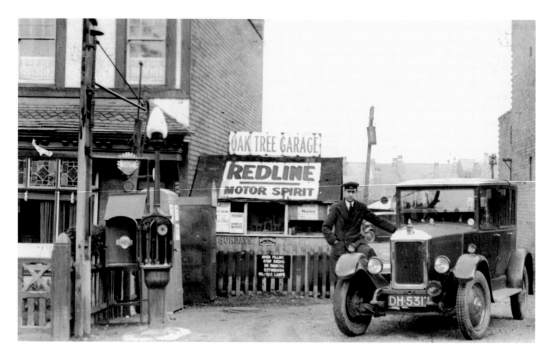

Watford Road

Number 86 Watford Road was built *c.* 1880 next to a commercial orchard. The old greenhouses were converted in car repair workshops and included a petrol filling station, private car hire and sales. George Lilley Jnr was a proficient driver from the age of twelve before he could drive on the roads. His son, John Lilley converted it into a caravan storage yard. It was sold for housing development in 2004.

Breedon Bar

The Breedon Bar, on the corner of Lifford Lane and Pershore Road, was once listed as a heritage building but years of vacancy led to vandalism. A fire made it beyond repair with an estimated cost of £70,000. The land was sold for a reported £420,000 and permission was granted to demolish the building and replace it with a block of flats. The location of Breedon Cross was certainly a crossroads before the canal was built. Lifford Lane is a relic of an ancient Roman Road from Parsons Hill to Metchley Fort.

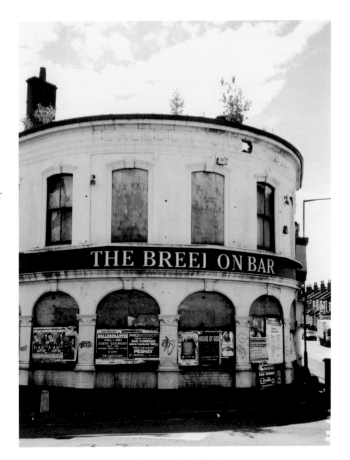

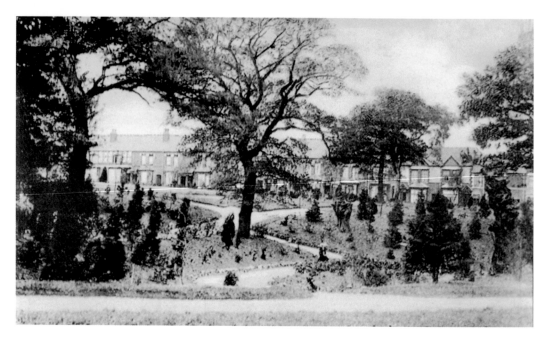

Cotteridge Park

The postcard from *c.* 1908 indicates the park was in Stirchley, but the houses in the background are clearly Franklin Road, which places it within the parish of Cotteridge. The land was part of the estate of Breedon House home of the Baldwin family. The park has 22 acres and was set up between 1905 and 1909 by the former King's Norton and Northfield Urban District Council. A Friends of Cotteridge Park group was formed in 1997 amid concerns about the park's future. The group have been very active and hold an annual festival and procession with floats.

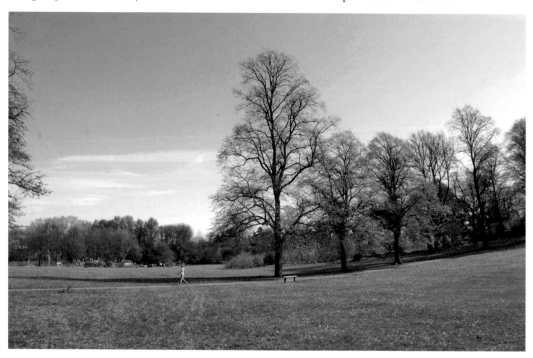

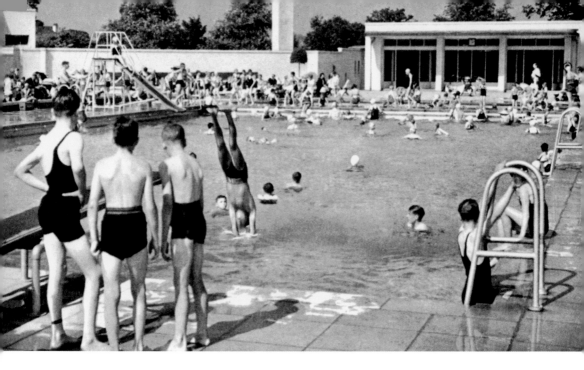

Rowheath Park

Rowheath Park was a popular social place. The lido was a favourite venue especially in the summer. The pool was reduced in size and squash courts added to the complex. Eventually, the need for housing and the uneconomical running costs caused this part of Rowheath to disappear. The Pavilion buildings underwent a facelift.

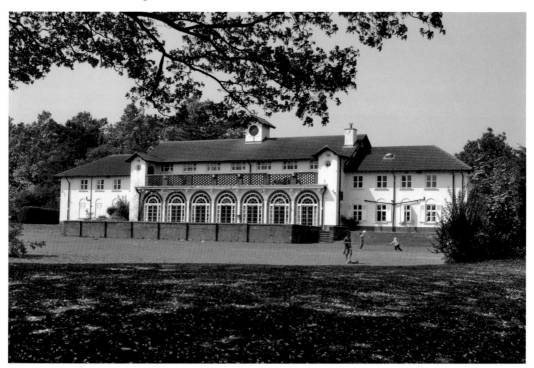

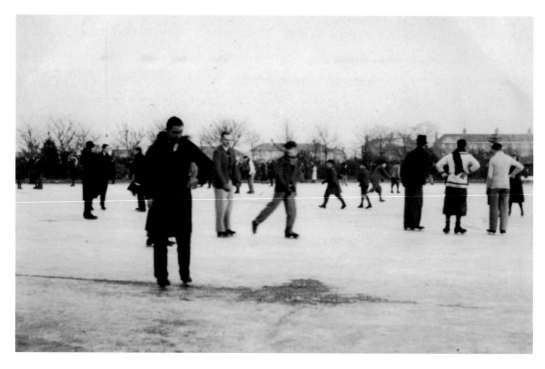

Rowheath Park
The inclement winters clearly brought these people out of doors to enjoy the big freeze of the pool. This remains an attractive place to visit. The playing fields can be congested especially at weekends.

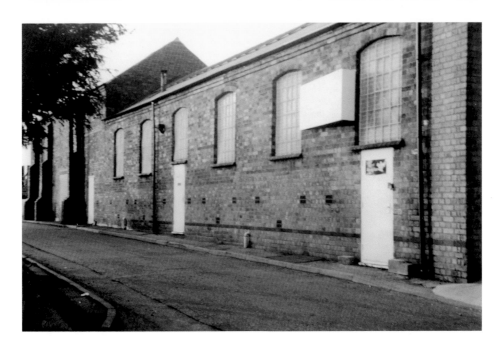

Hudson Drive

Hudson Drive was home to the first 'Picturedrome' in the area. It was opened in 1913 on the site of Hudson Brothers Ltd. Cotteridge Cinema Ltd was incorporated in 1913 and went into liquidation before 1932. The projector sometimes experienced technical difficulties and if a showing had to be cancelled a metal token was given to enable the children to have free admission to see another show. Local traders would advertise their products on the curtain that was wound up and down between shows. Mr Calvert was the manager and Mrs MacDonald assisted him on the piano. It is now a factory unit and a small estate has been built on the former industrial land at the end of the Drive.

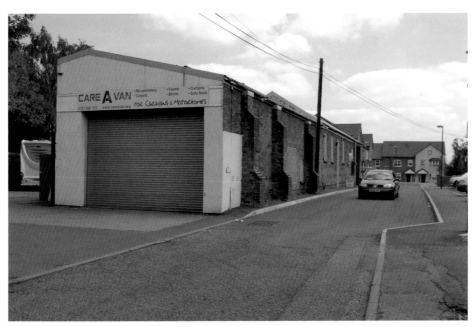

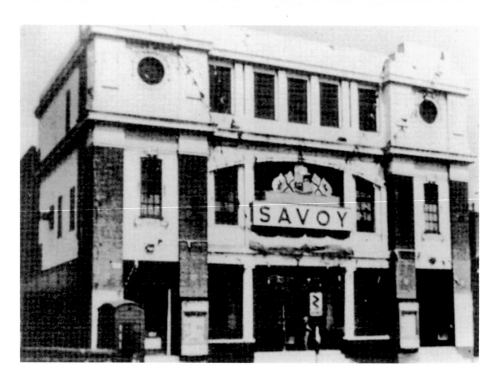

Savoy Cinema

In 1922, this building was opened as the 'Palace of Varieties' and replaced the picture theatre in Hudsons Drive. Mr Calvert became the manager, but sadly he died when he fell through the roof doing some building work. The name changed to the Savoy in 1932. It closed in 1958 and with a change in façade the building continued in use as Wyvern Engineering and then as Stirchley Forklift Company. Two other important buildings share the site; the small house which was possibly Breedon Lodge and Haye House which shows a date of 1862. Capon Heaton had their rubber works behind the house.

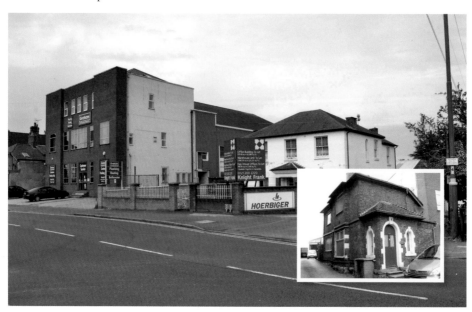